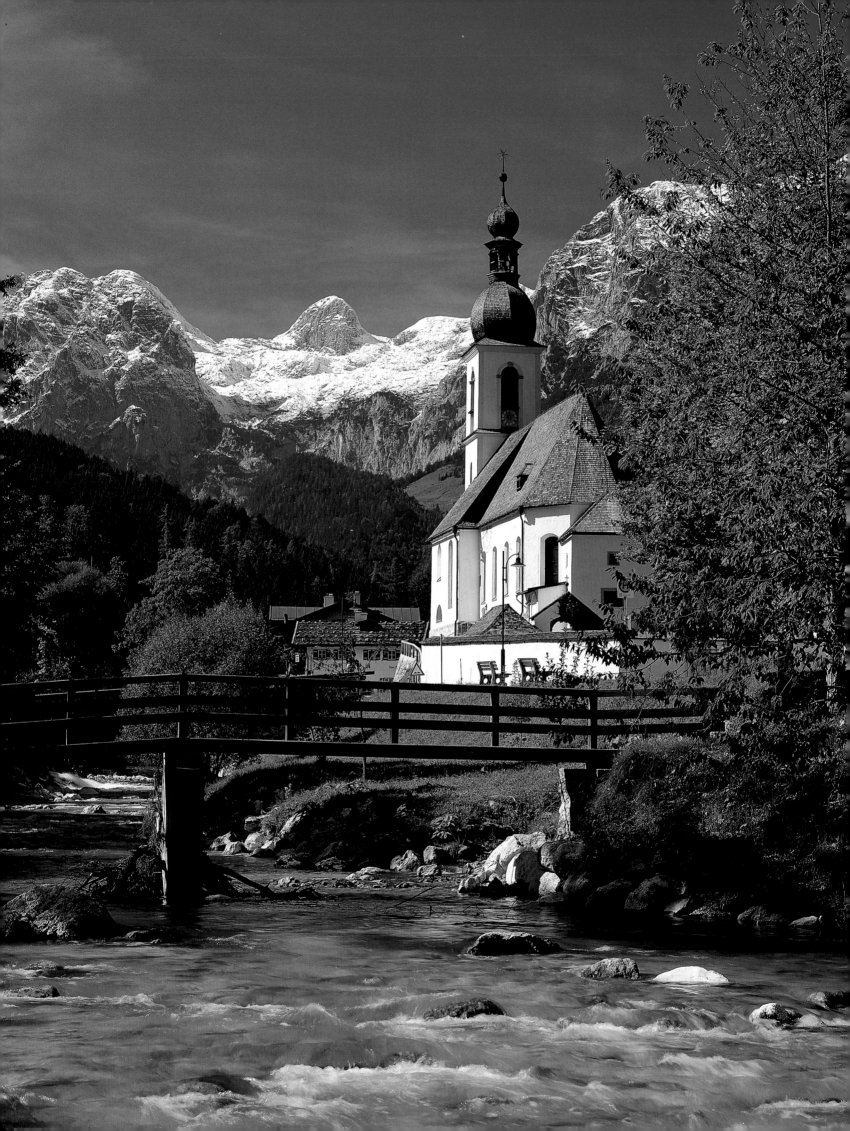

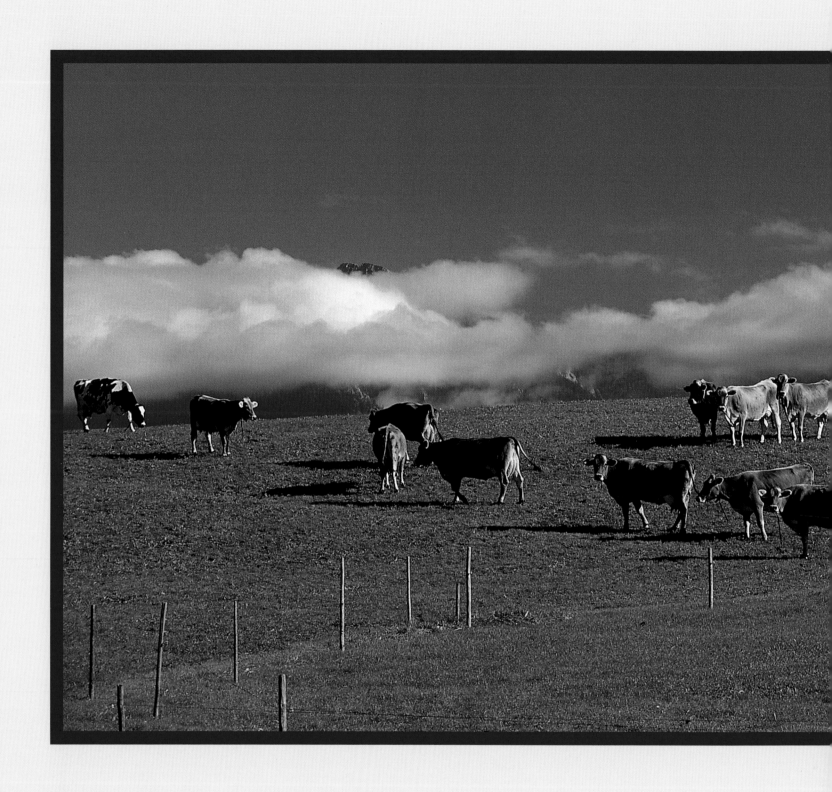

# BAVARIA

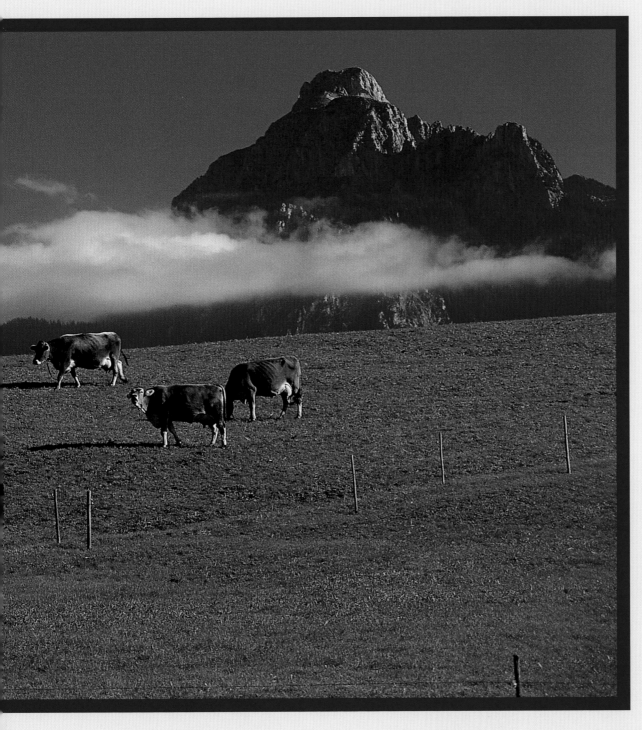

PHOTOS BY
MARTIN SIEPMANN
TEXT BY
ERNST-OTTO LUTHARDT

# CONTENTS

*Pages 8/9:*
At the Loisachgau Festival in Egling-Neufahrn. Today, every major festivity calls for as large a shelter as possible – if merely to ensure the weather does not spoil the fun. Nomen est omen – "Bierzelt" or beer tent – at least in Bavaria.

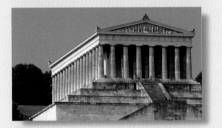

*Pages 12/13:*
The town on the Salzach, which profited from the salt trade, was first documented in 1025. The residence of the dukes of Bavaria-Landshut from 1255, from 1505 it was one of the Bavaria's four governmental seats over three centuries.

*Pages 14/15:*
Andechs Monastery, situated on the "Holy Mountain" on the eastern shore of the Ammersee, was founded by Augustinian monks in 1438 and soon later taken over by the Benedictine order. Today, it is one of the best-known pilgrim destinations in Germany.

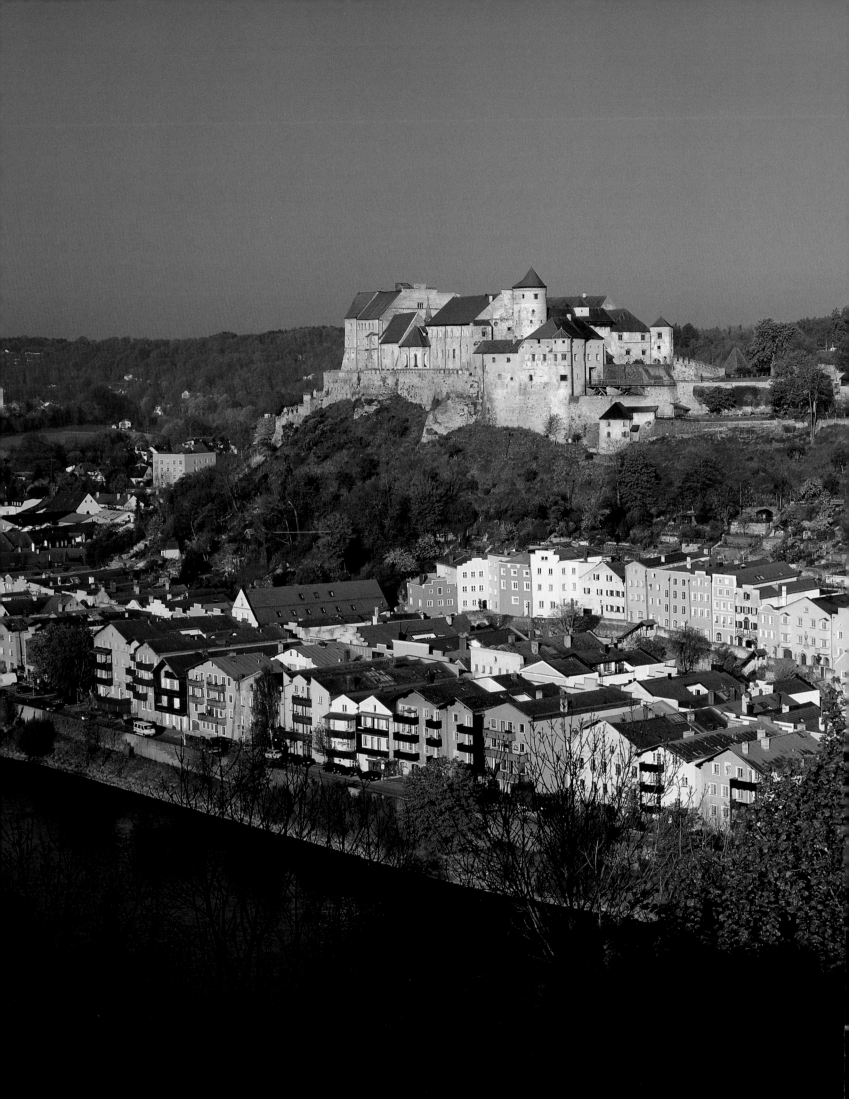

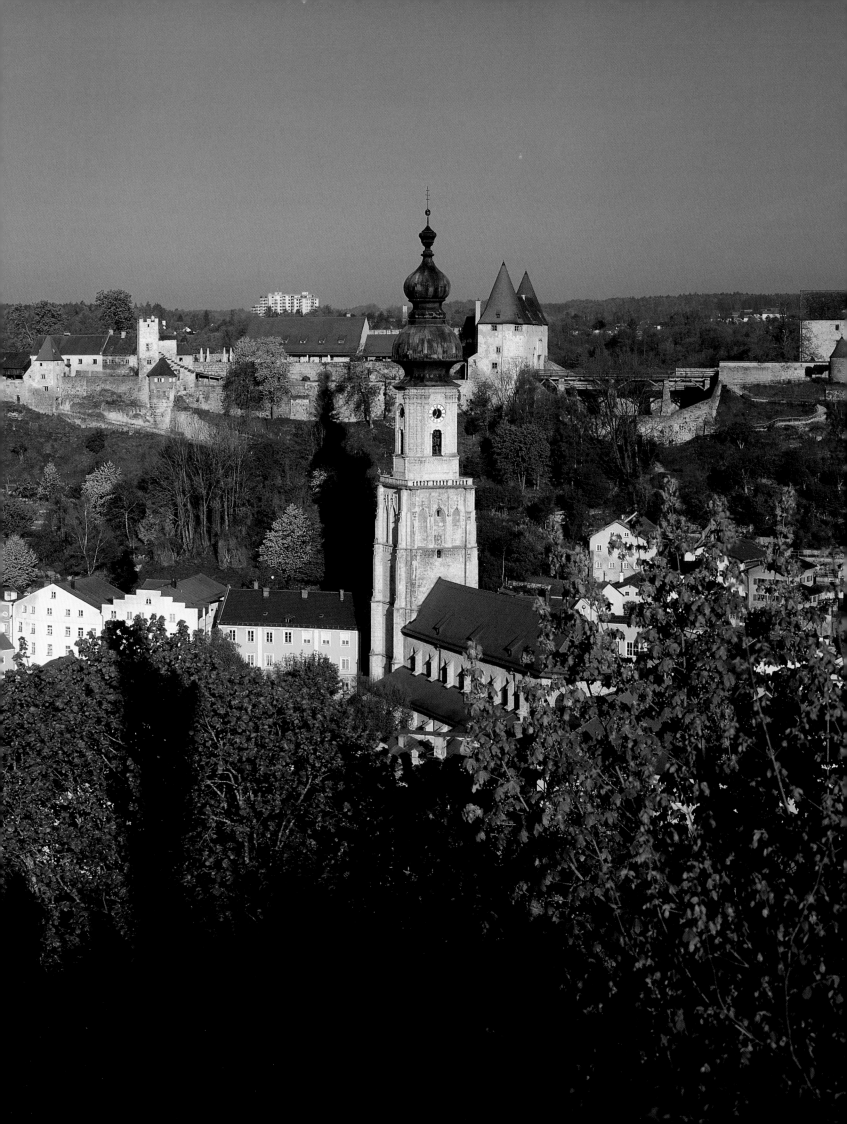

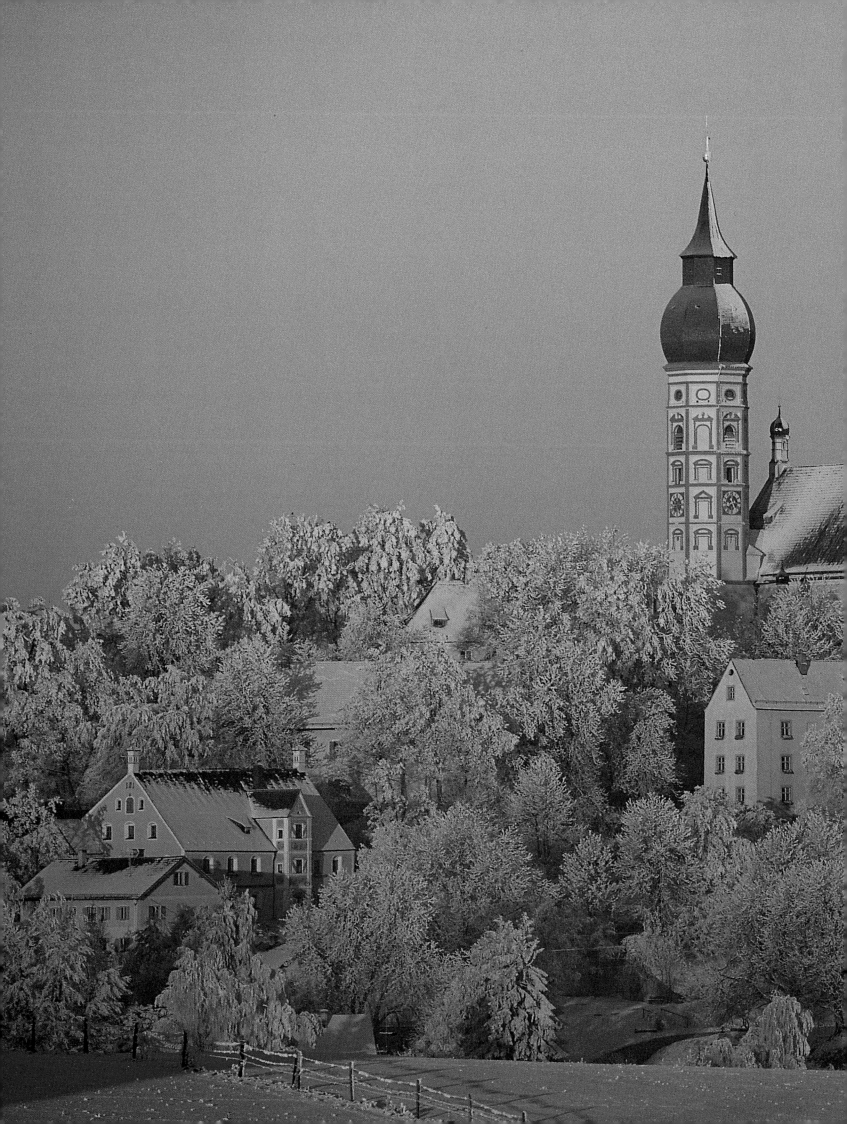

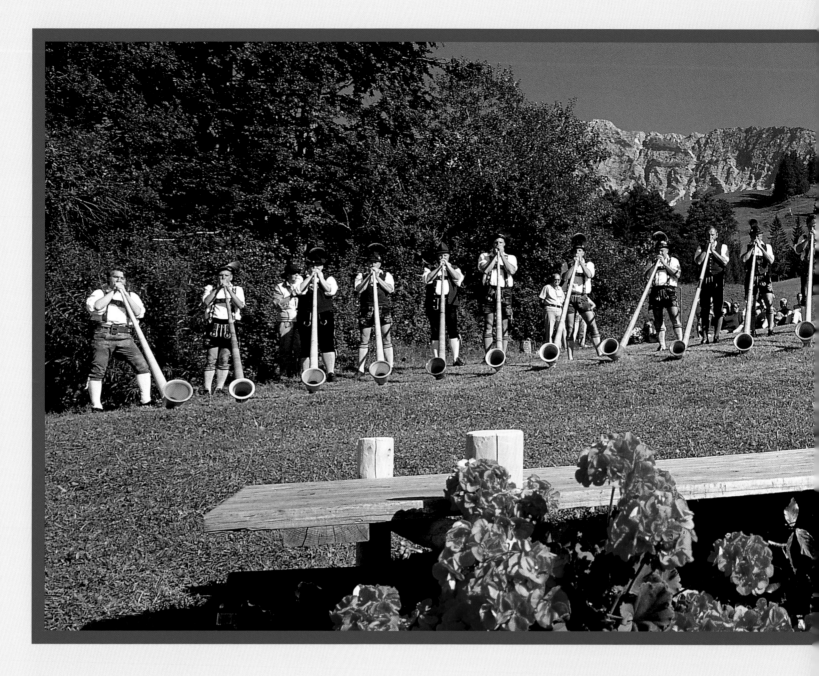

# BAVARIA —
# GOD'S LITTLE
# WHITE AND BLUE
# TREASURE CHEST

The oldest known Bavarian is one of the most famous. After all, he was the first to fly. That was about 140 million years ago. We mean the prehistoric bird Archaeopteryx, six specimens of which were found in the Solnhofen limestone. Admittedly, the little fellow's fossilized skeleton is not much to look at, but nonetheless he was the first to conquer the skies. He later tumbled down – the scientists say thank goodness – into the "Blue Lagoon," a flat expanse of water separated from a primeval ocean that would have glowed blue due to the high content of lime. Otherwise, we may never have discovered that Archaeopteryx ever lived. The first known people

16

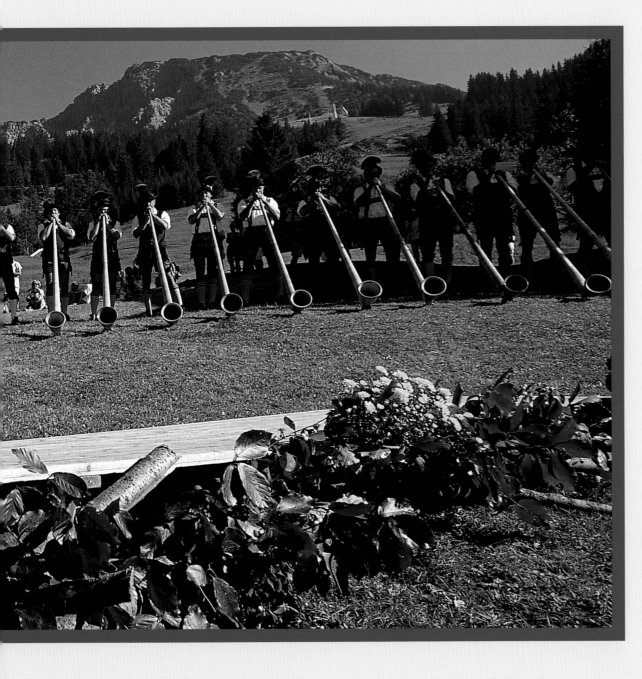

Hindelang has made a name both as a location for winter sports and for healing spas, but it's calendar of events also includes the Alphorn Festival on the Oberjoch, whose performers must have both strong lungs and strong backs.

between the Alps and the Danube were the Celts. They arrived here in the 8th century BC and were conquered by the Romans 15 years before the birth of Christ. Their new provinces were named Rhaetia and Noricum; military camps swelled into towns called Par-tanum (Partenkirchen), Castra Regina (Regensburg) and Batavis (Passau). The famous historian Tacitus went into raptures about Augusta Videlicum (Augsburg), "the most delightful settlement in the whole of Rhaetia." Numerous excavations have unearthed hundreds of relics from this period, the last spectacular find being in 1979 when, while digging an asparagus bed, a resident of Weissenburg in Middle Franconia happened

upon 156 tools and utensils from Roman times – the largest find of this kind ever taken from German soil and today housed in the "Römermuseum."

At any rate, the new lords staked out the northern boundary of their empire with the Limes. The Celts – at least those who didn't put up too much resistance – were assimilated. During the migration of the peoples, Germanic tribes mingled with the existing Celto-Roman population. Soon, the new amalgamation of peoples made a name for themselves as the "Baiuvarii." Their first rulers were the Agilolfing dynasty, followed – from

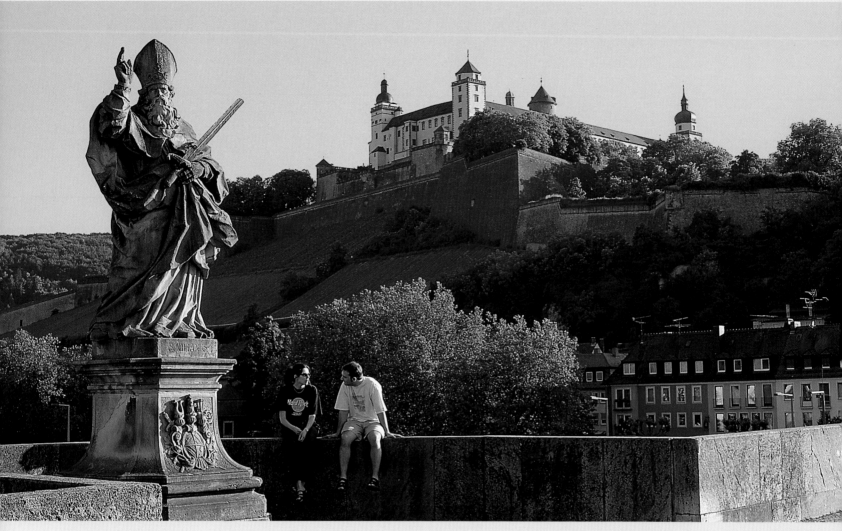

788 – by the Carolingians, the Luitpoldingers, the Salians and the Guelphs. Henry the Lion is considered the founder of Munich.

## A DURABLE DYNASTY – THE WITTELSBACHER ERA

1180 saw the rise to power of Otto I and the commencement of Wittelsbach rule which they defended – in spite of all change and peril, and even sometimes in spite of themselves – for over 700 years. The name Wittelsbach is inextricably linked to the obligatory military and political triumphs and disasters common to any influential dynasty as well as to rather more remarkable peaceful campaigns as well. In the Renaissance, these were assumed by Dukes Albrecht V and Wilhelm V, in Baroque times the electors Maximilian I and Max II Emanuel in particular, who

were very fond of the arts. The Rococo style in turn was promoted by the elector Karl Albrecht and his successor Max III Joseph. Of the Wittelsbach kings, Ludwig I may have become a laughing stock with his Lola Montez but he also did much to promote neoclassical art and architecture. His son and successor, Maximilian II, proved even a greater architect than his father, his name now used to describe a particular style of building. Today, the most popular Wittelsbachs are, of course, Ludwig II, the "Mad King," and his cousin, the Austrian Empress "Sissy."

## ON OLD BAVARIA AND "NEW ARRIVALS"

The "Democratic and Social Republic of Bavaria" has been in existence since 7 November 1918.

18

In 1934, the Free State of Bavaria was forced to cede its state rights to the Third Reich and was not given them back until after the war by the Americans. In 1946, the people endorsed the new, third constitution and three years later Bavaria became part of the Federal Republic of Germany.

With a surface area of a good 70,000 square kilometres (27,000 square miles), Bavaria is the largest federal state in Germany. It has around 12 million inhabitants spread out across "old Bavaria" (Upper and Lower Bavaria and the Upper Palatinate), Franconia and the administrative district of Swabia. The latter two territories were annexed during the Napoleonic era following several spectacular exchanges of land, the first under the auspices of Napoleon and the last – after the Bavarians had swapped sides during the Wars of Liberation – without any intervention on his part. However, considering that the map in those days was reminiscent of a brightly coloured patchwork quilt, this was not a bad thing.

Franconia, for instance, consisted of four ecclesiastical states (Würzburg, Bamberg, Eichstätt and the lands of the Teutonic Order of Knights, two margraviates (Ansbach and Bayreuth), a number of counties (including Schwarzenberg, Hohenlohe, Henneberg and Wertheim), five free imperial cities (Rothenburg ob der Tauber, Nuremberg, Schweinfurt, Weissenburg and Windsheim), six feudal cantons and a few imperial villages. Around 160 different Swabian "dominions" – some so insignificant as to hardly qualify for such a grand designation – were handed over to the Wittelsbachs. Among them, just 70 kilometres (43 miles) from Munich was the 2,000-year-old city of Augsburg. Its long and prosperous past makes the Bavarian capital almost pale into historic insignificance beside it. Munich saw neither Romans nor early dynastic potentates such as the Welsers and the Fuggers. These were able to bring kings and emperors into their debt, thus making them their dependants.

Luckily, the Swabians weren't around 15 million years ago; if they had been, they would have been

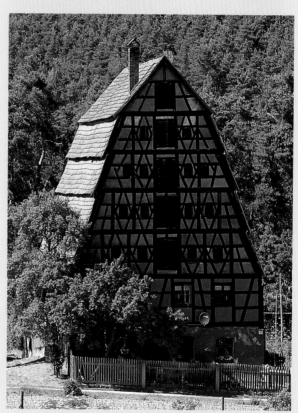

*Above:*

**Wayside shrines like this one near Escherndorf at the foot of the Vogelsburg testify to the piety of the Lower Franconians. The famed vineyards of this town are called the "Escherndorfer Lump," not delineating a bulge, but the way they were once split up into tiny parcels of land called "Lumpen".**

*Above left:*

**View of Bad Berneck with the castle tower in the background. Close to Bayreuth, the town is called the "Pearl of the Fichtelgebirge," referring both to the picturesque townscape and the former sweet-water pearl farming in the waters of the Ölschnitz.**

*Left:*

**The little town of Spalt is the centre of Franconian hops farming, which, according to records, has been going on here since 1341. The harvest was dried and stored in the attics of the high gable houses, the loveliest example of which is the Mühlreisig House from the mid-18th century.**

obliterated by the giant meteorite that came hurtling down into Swabia, leaving behind the enormous Nördlingen Ries crater. Germany would have then been a far poorer place with neither the famed Swabian thriftiness nor keen sense of business such as that of Sebastian Kneipp, the priest from Wörishofen, who in true Swabian fashion used water – the cheapest healing commodity available – to great effect. We would also be lacking the pictures of Hans Holbein, the music of

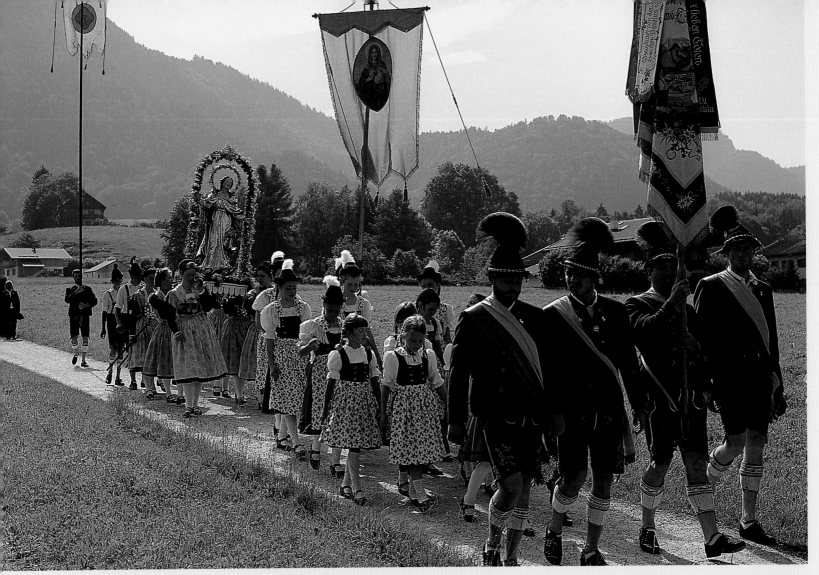

**Church festivals in particular play a major role in life in Upper Bavaria, where traditions and customs have been preserved longer than elsewhere. One of the most magnificent is Corpus Christi, which culminates in large processions like this one held in Unterwössen in the Chiemgauer Alps.**

Wolfgang Amadeus Mozart (whose great-grandfather was a native of Augsburg), the engines of Rudolf Diesel, the books by Bertolt Brecht and the football goals of Helmut Haller.

A favourite Bavarian dish and its Franconian rival
This section is dedicated to two or three sausages. The first, Weisswurst, true to its name, is white and perhaps the most Bavarian of all Bavarian sausages. Its story began on 22 February 1857 thanks to the cleverness of a journeyman butcher named Sepp Moser combined with the impatience of some tavern guests. They wanted Bratwurst, but the kitchen chef had just run out of thin sausage casings. He only had thick ones left. Then, because he was running out of time, he didn't bother to fry them, but served the sausages right from the scalding pot. Instead of earning the malice of his hungry guests, the man was rewarded by praise, as well as the fame of creating a culinary bestseller.

Although over the course of time the old Bavarian Weisswurst moved far into Franconian territory,

it continues to meet hefty resistance from the queen of sausage thereabouts, the Bratwurst. Mentioned in a Nuremberg chronicle as early as the mid-14th century, and hence earlier than anywhere else in Germany, the Bratwurst is a sausage of familial contention. While the Nuremberg Bratwurst is famed for its tiny size, the local Bratwurst in Coburg may only be grilled over glowing pine or fur needles.

If you think this is the end of the Bavarian-Franconian sausage history, you're very wrong indeed. For we now know that the inventor of the world-famous "Wiener" was not born along Vienna's blue Danube, but in the tiny village of Gasseldorf by Forchheim. If Johann Georg Lahner had stayed home rather than moved to the Austrian metropolis at the age of 32, his sausages would be called "Gasseldorfer" making them a third rival in the sausage battle.

In no other German metropolis do old and new abide so closely side by side as in Munich.

Although the reason for introducing the original custom, the plague, is now well behind us, Munich still performs its "Schäfflertanz." Traditional alpine costume competes with haute couture in Munich, too, which is home to some of the country's most prominent and most eccentric fashion designers. Indeed, Munich knows how to put on a show. It offers discoveries, surprises and countless superlatives to please any interests.

It is home not only to the Deutsche Museum's technical collection, unrivalled in Europe, equipped with a planetarium and IMAX cinema, but also to the Alte and Neue Pinakothek, the newly

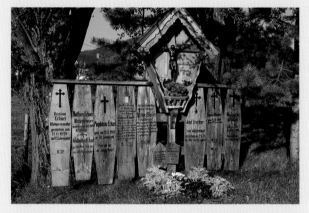

added Modern Pinakothek, the Glyptothek and many other museums, art galleries and concert venues.

The city's quality of life can be read in figures as follows: the approximately 1,300,000 inhabitants and three times as many guests have 70 theatres, 80 cinemas, almost 250 places of worship, nearly 4,000 sport facilities, roughly 7,000 shops, far over 4,000 pubs and its beer gardens seat 120,000. Don't forget the annual Oktoberfest, two famous football clubs and many famous footballers.

When the populace is worn out by all of that, it can seek out the city's "green lungs" – first and foremost the English Garden. No other big German city can call such a oasis of nature – measuring five kilometres (3 miles) in length and one kilometre (over half a mile) in width – it's own. Not to mention the ubiquitous beer gardens. The Chinese Tower is a guiding light from afar. Then there are the park landscapes girdling Munich's

waistline, offering a colourful framework of trees, meadows and flowers to the fairytale palaces of Schleissheim and Nymphenburg.

## ON THE ROOF OF GERMANY

Travellers passing through Bavaria back in the early 19th century were amazed to find high mountains here and not just in Austria. The Alps were long a white spot on the map, a terra incognita, believed the home of monsters, ghosts and other creatures of the night. One of them was the legendary King Watzmann, whose wild hunting forays could be stopped by nothing – until God himself intervened and transformed the fiend to stone.

Not only did the King's contemporaries profit from God's judgment; we still do today. The Watzmann range is undoubtedly the most striking massif on the German side of the Alps with the stony king still holding his head high. The only peak closer to the heavens than the

*Left:*
**"Totenbretter", on which the deceased were laid out prior to burial, at Weiherhof near Teisendorf. These carved and painted panels are set up after the burial under trees or by a chapel.**

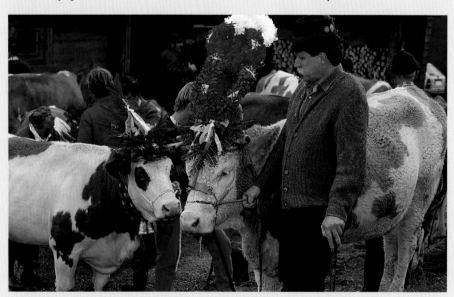

*Above:*
**Driving the cows home from the alpine pasture. For this important event in the farming year, not only the people dress up, even the animals are adorned.**

Watzmann in these parts is the Zugspitze. It appears to be proudly showing its surroundings a (gigantic) cold shoulder: no other mountain face in this part of the Alps is as high and as dangerous as the mountain's eastern flank, which drops 2,000 meters (6,566 feet) almost vertically to the depths.

*Right:*
**Every September for the Reichsstadt festival, tourist-thronged Rothenburg ob der Tauber almost bursts at the seams. The many-day spectacle in Germany's romantic display town also involves an historic army camp.**

*Above right:*
**According to native patriots, Bratwurst is Franconian. Yet there's plenty of regional sausage rivalry. Both the Nurembergers and the Coburgers claim to have the very best sausages.**

*Above:*
**In Bavaria, where nearly everything revolves around a beverage brewed from water, barley malt and hops, beer gardens are a national institution of sorts. The "Reinheitsgebot" (Purity Law) will be 500 years old in 2016.**

Contrary to the inhospitable Watzmann, the Zugspitze, located in the Werdenfelser Land, the heart of the Bavarian Alps, is more welcoming. Four cableways – one of them on the Austrian side – carry more than half a million visitors each year to the top of Germany's highest mountain. Up there, at a height of almost 3,000 meters (10,000 feet), the world lies at your feet and you are the lord of four nations and roughly 400 mountaintops. The best way to get up on the roof of Germany is to take the German Alpine Route (Alpenstraße), which links the Allgäuer Alps in the west with the Chiemgauer Alps in the east.

## LAKES OLD AND NEW

The moraine landscape north of the Alps is the child of Ice Age glaciers. Here, numerous lakes are sprinkled between forests and meadows. While the lakes Starnberger See, Ammersee, Staffelsee and Chiemsee are situated in hilly land, once you reach the Schliersee, Tegernsee and Königssee the Alps tower above.

The largest waters of the five lakes region are the Ammersee and Starnberger See. The latter in particular has longed served the Munich population as their favourite bathing and recreational spot. Yet before the common folk were allowed to amuse themselves here, the Bavarian nobility held court. The first flotilla, in the 16th century, belonged to Duke Albrecht V, the largest to Elector Ferdinand Maria and his spouse Adelheid of Savoy. With the ambition of creating an illusion of the beloved Mediterranean in their own land, they turned the Starnberger See into a Baroque water theatre. The main attraction of these shows was a ship fashioned after the grand galleys of Venetian doges, put in motion by 150 galley slaves and accompanied by a whole fleet of gondolas and boats. At the big festivals, 2,000 people were sometimes on the water. Nevertheless, our times have long surpassed even this superlative. The electoral couple would be astounded at today's hustle and bustle at and on the upper Bavarian lake.

The Chiemsee is especially popular among Bavarian leisure-time captains. Lacking proper maritime conditions and with their own typical pride they call it the "sea." The lake does indeed cover

a staggering 80 square kilometres (30 square miles) and when a violent storm whips up the water, the comparison is a fair one. The little Königssee, by comparison, may only be navigated by low-noise electrical boats.

The counterpart to the Upper Bavarian lake country has only existed since the 1980s, when the waters of the Danube and the Altmühl were dammed to form the lakes Roth, Altmühl, Igelsbach as well as the lesser and greater Brombachsee. The "new Franconian lake country" in the north of Bavaria owes its existence to the construction of the Rhine-Main-Danube canal. While the rationale and usefulness of this water highway are disputed, its resultant new lake landscape is met (almost) entirely with praise.

## HEAVENLY PRAISE AND WORLDLY DESIRE

Christianity became established in Bavaria under the Agilolfing dynasty – the earliest duke on record is Garibald (ca. 550–590). The saints who brought the faith in the 7th century were named Emmeram and Rupert, Korbinian, Willibald and Kilian. Boniface, who founded the dioceses of Regensburg, Passau, Salzburg and Freising in 738/39, deserves the most credit for the establishment of church structures. The first monasteries also date from this period. Since the monks manifested their service to God in architecture, painting, music and literature, as well as in prayer, many monasteries became centres of art and culture.

The Benedictines of Wessobrunn made great contributions to a number of fields. German poetry was born with the "Wessobrunn Prayer" of 814. Medieval writers and book artists were followed in the 18th century by scientists and stucco artists. The "Wessobrunn School" stands for the brilliant combination of architecture and sculpted decoration. The Zimmermann brothers in particular created unsurpassed masterpieces; the most beautiful is the Wies Church, a UNESCO world heritage site.

In the mid-11th century, a monk at Tegernsee Monastery wrote the first work of fiction. The knight "Ruodlieb" is the title character of the epic poem written in Latin but already interspersed with many German words. About 100 years later another Tegernsee monk named Werinher wrote one of the most beautiful love poems of all time: Du bist min, ich bin din:/des solt du gewis sin …

In 1803, a manuscript of medieval goliardic verse was discovered at Benediktbeuern Monastery – songs of nature, of drinking, of mockery and of love sung by travelling players and scholars. Set to music by Carl Orff in 1937, today "Carmina Burana" is one of the most-frequently performed pieces of classical music.

No cultural journey through Bavaria is complete without an encounter with the Baroque fresco and stucco marvels of the Asam brothers. In addition to Munich, Freising, Fürstenfeld, Tegernsee and Ingolstadt, their work can be found primarily in the eastern part of the state. In the Upper Palatinate, we find their art at religious sites of Regensburg, Amberg, Ensdorf and Michelfeld; in Lower Bavaria in Osterhofen, Rohr, Kehlheim, Aldersbach and Straubing.

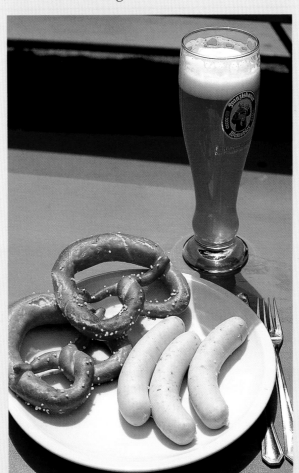

**The most famous example of real Bavarian food is the Weisswurst. It came to be on 22 February 1857, when the butcher Sepp Moser ran out of both Bratwurst and thin casings and had to serve the sausages straight from the scalding pot.**

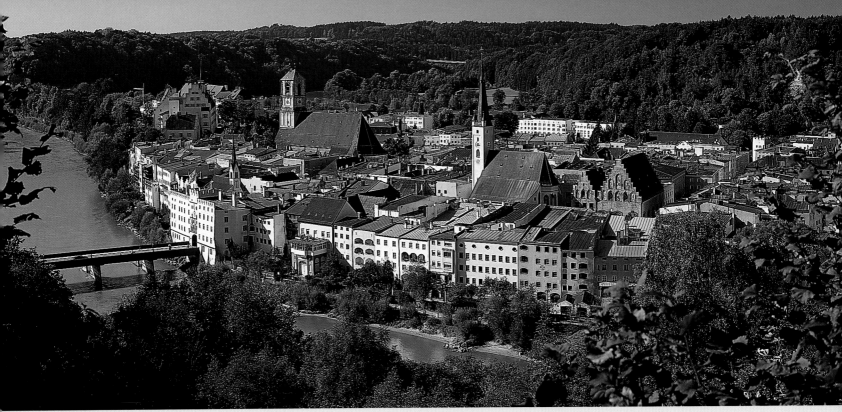

# LONG LIVE CHEESE!

A Swiss confederate wandered into the Allgäu in 1827 bringing with him a recipe for turning simple milk into delicious golden cheese. Once the natives acquired a taste for it, they imported the brown Swiss dairy cattle to Bavaria as well, and thus began the unstoppable rise of Allgäu to cheese country.

There are around 400 types of cheese made here with over double that amount of flavours; nowhere else in Germany is so much of it manufactured as here in the Allgäu. Nevertheless, consumers still prefer good old Emmental cheese the best. Around 14 litres (25 pints) of milk are needed to produce one kilo (2.2 pounds) of this preferred variety. That's about the amount of milk one cow can produce in a day – if the pastureland is suitable, as it is here. Tending the meadows is the job of dairymen and women and no easy task. Despite knowledge to the contrary, their way of life is still popularly depicted as idyllic. Even after experiencing the unwelcoming interior of an Alpine hut or watching the farmers hard at their backbreaking work, the cliché still holds that life here is made up endless fun and frivolity. Maybe the increasing coldness of our society cries out for an escape such as this, a place of romantic fancy that our imagination does its utmost to preserve. Admittedly, much has changed. Production of milk and cheese has been industrialized where possible and mobile phones have done much to banish the loneliness of life on the Alms.

# "IN THE DEEP, DARK WOOD" OR "ON THE ART OF FELLING A TREE"

For centuries in the Bavarian Forest or Bayerische Wald (together with the bordering Oberpfälzer Wald central Europe's oldest and largest forest mountain range), timber was the hub of life. The people lived with it and from it. It served as building material for the houses and first smelted the ore and later the famous glass. Even after death, it remained useful, inviting the deceased to rest in state on wooden boards and slowly bid farewell as to a friend. After burial, these carved and painted "Totenbretter" were set up at a chapel, or nailed to the walls of houses or to trees, to be linked once again to their origins. With them the people, who were given their support on their way across that threshold we call death. It is no wonder that here the proper use of wood is still very

important. It was a woman of the wood who is said to have urgently advised:

*Tear out ne'er a tree yet young,*
*Leave your fresh-dreamt dreams unsung...*

Today, many people still hold to the tradition of felling a tree only in winter and – if possible – making sure that its top falls towards the valley. Moreover, its top and branches should not be removed at once, but left lying awhile. In this way, the law of gravity ensures that the water remaining in the tree collects in the branches and treetop. The less moisture in the wood, the less it shrinks and splits and the longer it keeps.

Otherwise, much has changed here. While in earlier days the inhabitants of the "forest" were pitied, today it's the down-to-earth way of life and relative intactness of nature that appeals to visitors. The 25,000 hectares (approx. 61,700 acres) of the Bavarian Forest National Park are a great attraction; a place where bears, wolves, lynx and aurochs have been reintroduced and are again learning to get along with human neighbours.

# AT GERMANY'S MOST FAMOUS CHRISTKINDLESMARKT

Nuremberg's Christmas Market is not the oldest, but it is the best known. Every year in December, people crowd the main marketplace beginning early in the morning. "Then the entire square is covered with wooden huts in which all sorts of wares are put up for sale," states an article dating from 1697 and since then, nothing has changed. Special gifts to take home from Nuremberg include the sweet "Zwetschgenmännla" (damson plum men), who seem to mock the anti-aging mania with their wrinkled bodies, and their counterparts, the stylishly outfitted "Rauschgoldengel" (Dutch metal angels). The latter is said to have been created by a local artisan who – after seeing his deceased little daughter in a dream as a magnificently adorned angel – took up his carving knife to make the

head and fashioned the dress and the hat, the "Rauschgold," from thinly pressed sheet brass. The public were so delighted with his angel that the good man was soon unable to satisfy the huge demand.

*Left:*
**At a certain mysterious hour, the castles of Neuschwanstein and Hohenschwangau flirt with the Alpsee and increase twofold on its surface.**

*Below:*
**The old salt works in Bad Reichenhall reflect the long tradition of salt mining. The main pump house erected in neoclassical style is an architectural eye-catcher.**

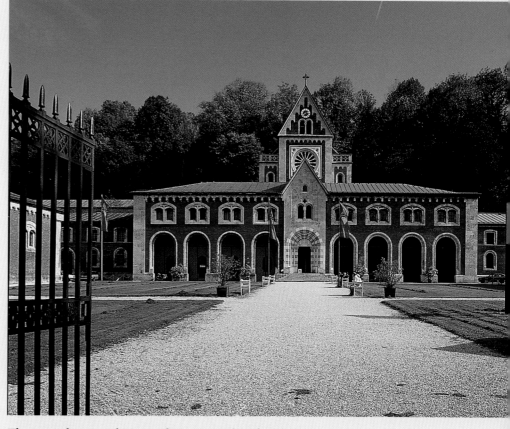

There is also a real Nuremberg speciality for the taste buds. The famous Lebkuchen is consumed all year round, but tastes best at Christmastime. Although there has long been competition, connoisseurs still swear by Nuremberg Lebkuchen. The local bakers make the very best "owing to the native water and air" as the clever people of Nuremberg informed a writer, who promptly spread the tale in 1673.

*Pages 26/27:*
**Nuremberg roofscape backed by the 13th century Sebaldus Church and the castle.
The three-part fortress was expanded and rebuilt a number of times and includes an imperial, a burgrave and a city castle.**

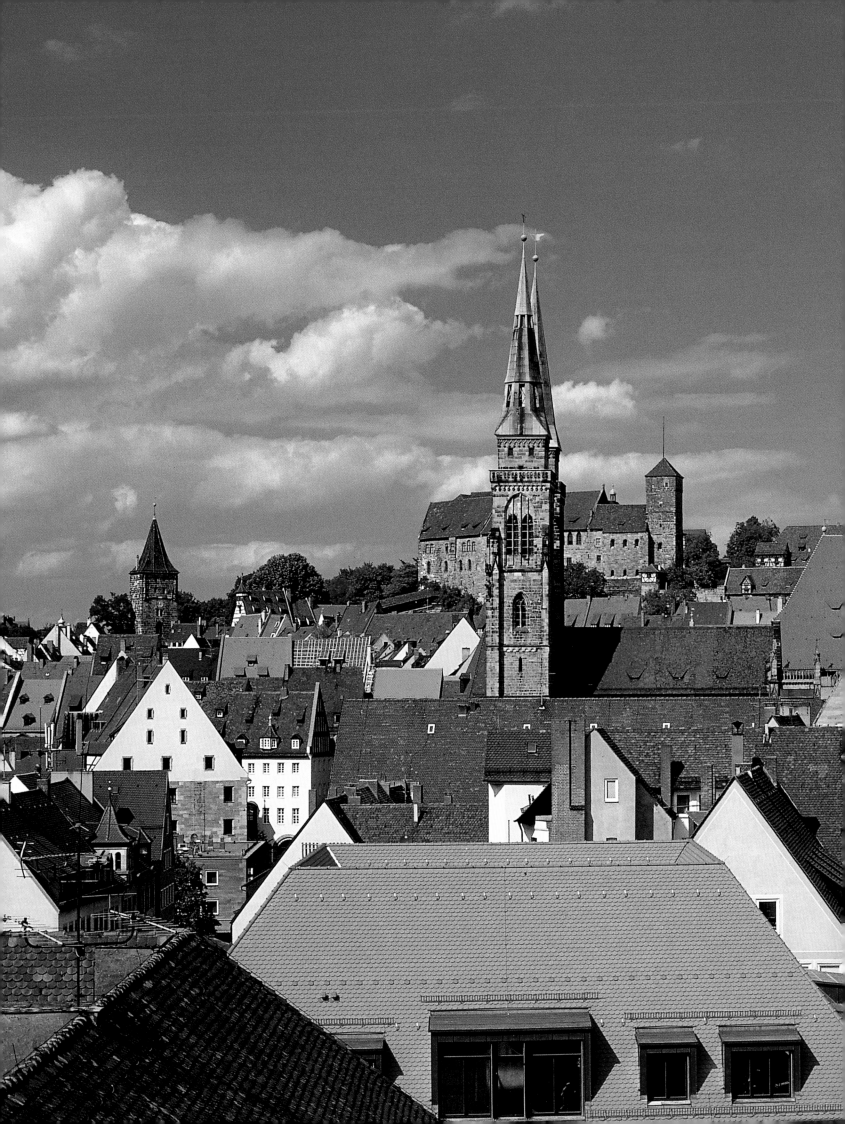

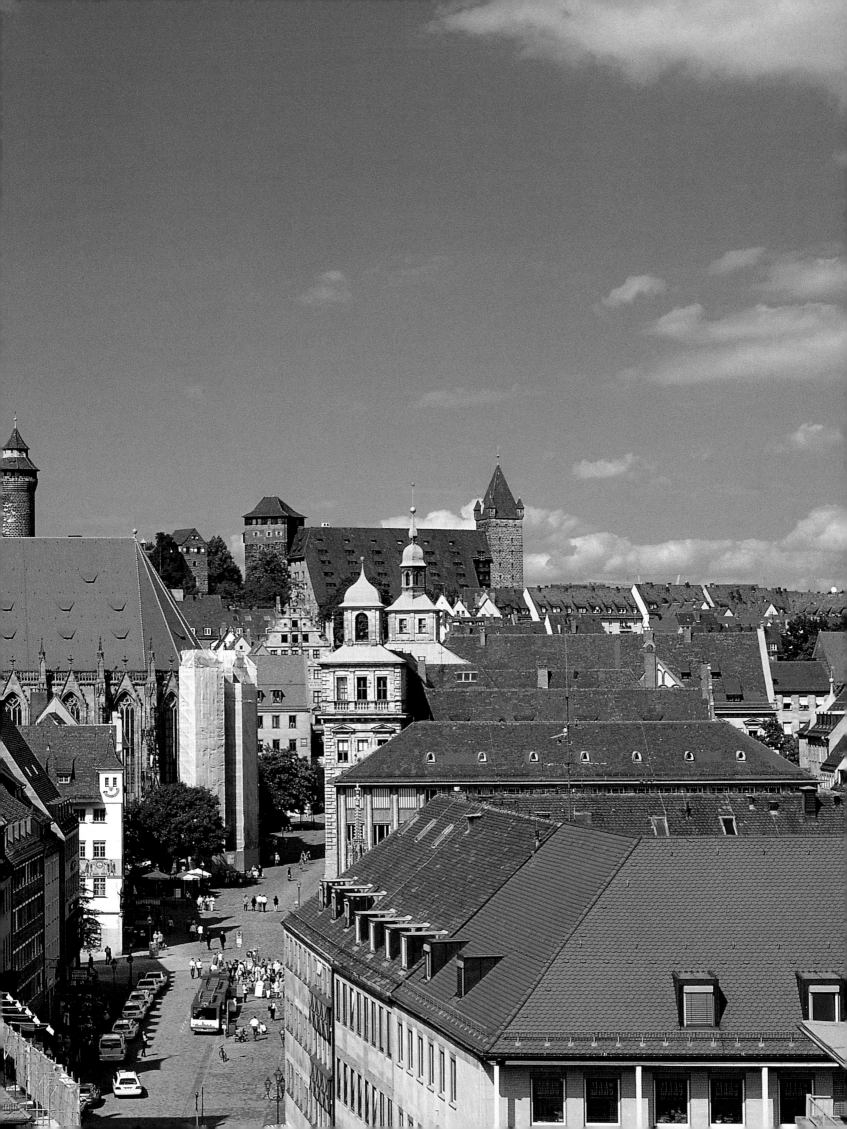

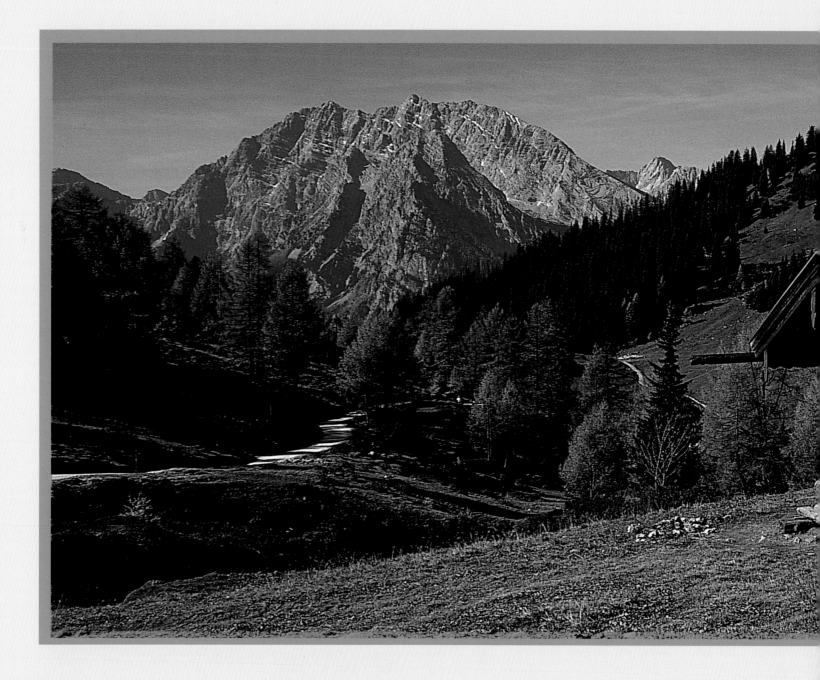

# FROM UPPER BAVARIA TO ALLGÄU

Although it only makes up about one fourth of the state, for many Upper Bavaria is the ultimate. Bordered to the south by the Alps, to the north by the Altmühl, to the west by Lech and to the east by the Salzach, the great advantage of this almost ideal holiday region is the peoples' inimitable blend of earthy roots to their native soil and warm hospitality – not to mention the magnificent natural scenery of constantly changing backdrops. Visitors feel that they have come to see a play populated by many original and distinctive characters.

The curtain opens in the north at the Fränkische Alb (Franconian Alb). In spite of the interven-

*Pages 28/29:*
**View of the Soiern peaks from Wallgau near Mittenwald. The Karwendel Mountains, shared by Austria and Bavaria, are sparsely populated, little developed and most of their area is under nature conservation.**

**The Berchtesgadener Land is a popular and highly frequented holiday destination in summer and in winter. On the right, we see the 1,874-metre (6,153-foot) high Jenner peak and on the left the Watzmann. The latter group of mountains with the central ridge, "Watzmann's wife," as well as the five "Watzmann's children" is certainly the most distinctive in the German Alps.**

tions of humankind's powerful roads and waterways, the Altmühl valley, with its glowing white chalk cliffs, dark juniper slopes and knightly staffage of castles is still a place of romantic longing. The ancient bishops' town of Eichstätt played a pivotal role in the Christianization of the country. In 741, St Willibald built a monastery here. In Heidenheim a convent was founded by his sister St Walburga, whose name goes down in a very different legend as well: on every first night of May, called "Walpurgisnacht", the witches and demons are set free. Johann Mayer von Eck saw a demon in Martin Luther. Von Eck was a professor of theology at Ingolstadt University and one of the most influential opponents of the father of the Reformation. His workplace, the "High School," was also the first institute of higher learning in all of Bavaria.

# MUNICH –
# A COSMOPOLITAN
# CITY

After Ingolstadt, the Jura curtsies to the Danube. Close by, celebrated hops grow in the good loess soil of the Hallertau region. This soil, transported here ages ago by the wind, has long ensured that Bavarian beer contains only the very best ingredients.

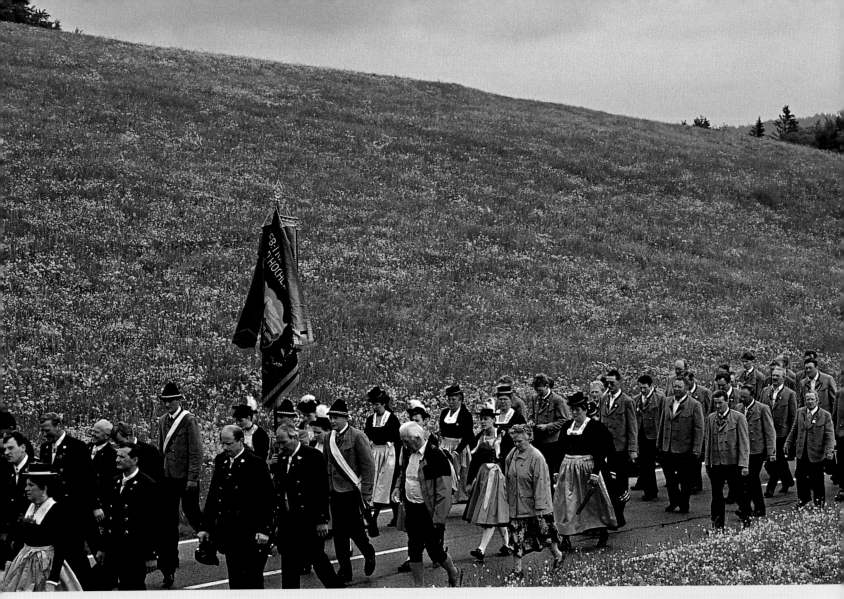

The scenery of the stage is speckled with gravel, brought here by Ice Age glaciers. It and the intermezzo of moors near Dachau and Erding seem to make time stand still. Luckily, Munich can successfully counter this. In no other German city is modern industry, finance and science so closely linked to homegrown traditions. Even those who have long been infatuated with the city are surprised that the object of their affections is able to gain in attractiveness year after year. Maybe it's the "good country air," as author Ludwig Thoma once assumed. But seriously, even today the great metropolis thrives on the small and sometimes narrow, yet vital Upper Bavarian world, to the benefit of the roughly 1.3 million people who take advantage of the good life offered here. Even the proud mountains seem to get curious and move in closer – when the warm "Föhn" wind plays along.

## MOUNTAIN RICHES

Speaking of mountains: fifty in the Allgäu surpass the two-thousand-metre (6,500 foot) mark. Hochvogel is the highest summit of the Allgäuer Alps, at over 2,590 meters (8,500 feet). It and the other main peaks are linked by an extensive

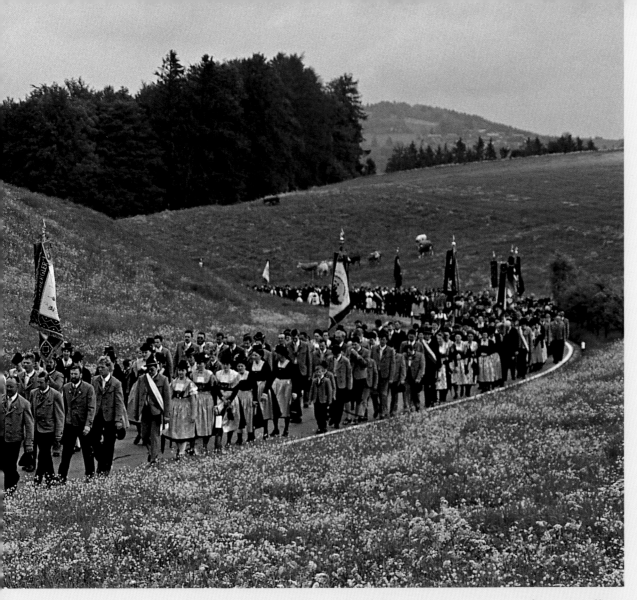

network of mountain paths covering roughly 60 kilometres (38 miles) and unequalled in the Alps. This makes the region a paradise for mountain hikers, not to mention winter athletes, who have ski runs, cross-country courses, ice-rinks and ski-jumps at their disposal in the middle of spectacular surroundings. Oberstdorf became especially well know for the Heini Klopfer ski-jump, one of the sites of the annual four-jump tournament.

Down below, between the rich green hills of the Lower Allgäu, picturesque towns like Memmingen, Kaufbeuren and Mindelheim age gracefully. Close by is an over 1,250-year-old famous monastery – Ottobeuren – and in spa towns like Bad Wörishofen the water, mountain air, plants and even the beer (Nesselwang) guarantee pure wellness.

The biggest tourist attractions of eastern Allgäu – besides quaint towns like Pfronten and Füssen – are the royal palaces of Hohenschwangau and Neuschwanstein. The latter and the Upper Bavarian palaces of Herrenchiemsee and Linderhof are among the fairytale legacy of "Mad" King Ludwig II, and are viewed in awe each year by millions of visitors from around the world.

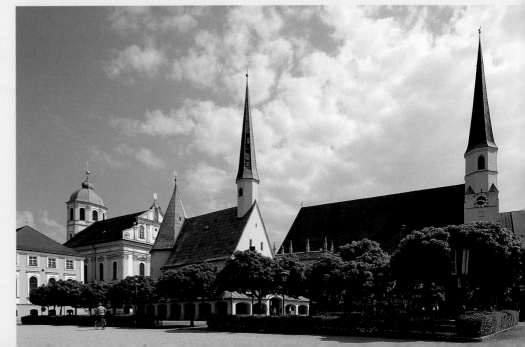

*Right-hand page:*
One must first climb all of the 302 steps of the tower of St Peter's in order to enjoy this magnificent view over Munich's Marienplatz – with the New Town Hall (1867–1908) and the Cathedral of Our Lady (1468–1488), the bishopric church of the southern Bavarian church provinces.

Munich's Karlsplatz, fondly called "Stachus" by the locals, got its name from Elector Karl Theodor, who in 1791 razed the second ring of walls that had girdled the town since 1319. A fountain was erected on the half-circle in 1972.

Leopoldstrasse in Schwabing. The town became part of Munich in 1891 although it was documented long before the state capital in 782 as "Swapinga." At the turn of the 19th to 20th centuries, poets, musicians, actors and painters settled here thereby founding Schwabing's reputation as an artists' quarter.

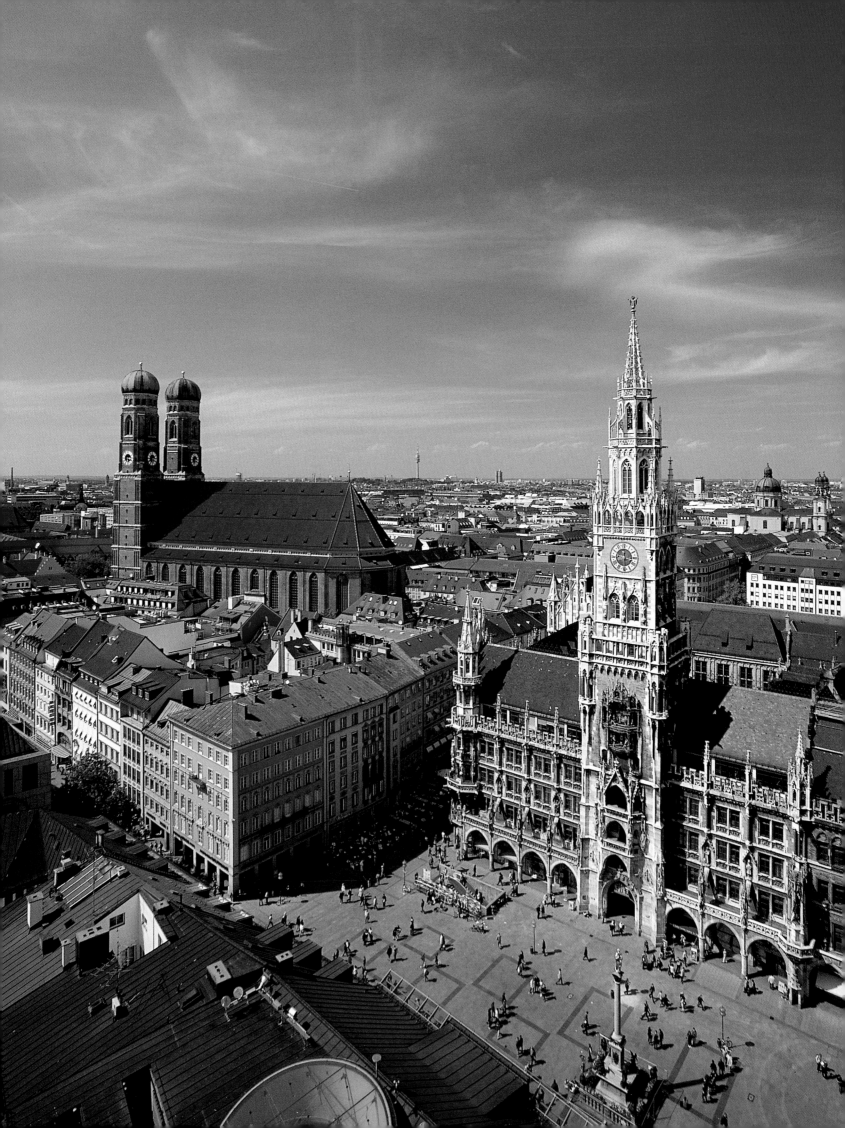

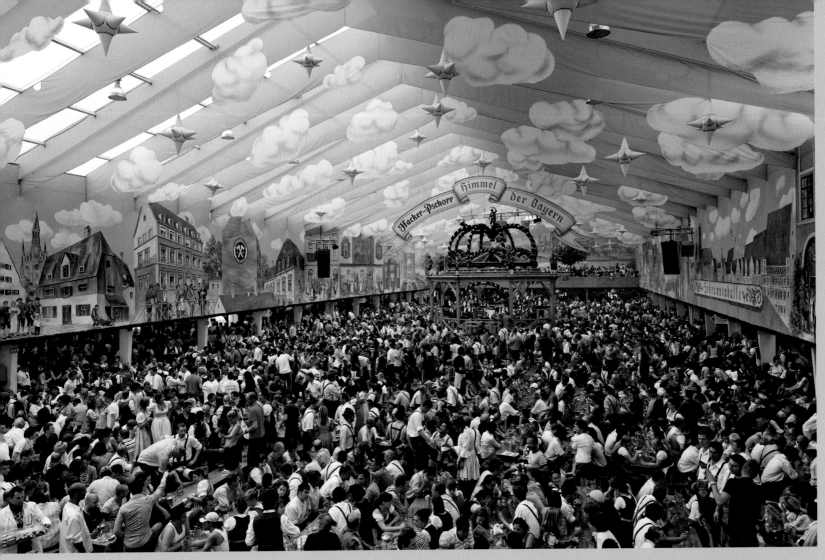

You can count yourself lucky if you manage to find a seat here; by midday the place is full to bursting! Guests to the Hackerbräu tent can imbibe not only enormous glasses of the local brew but also tuck into various festival fare, such as traditional *Weißwurst* (white sausages), *Hendl* (chicken), *Steckerlfisch* (fish kebabs), *Kalbshaxen* (veal trotters) and roast oxen.

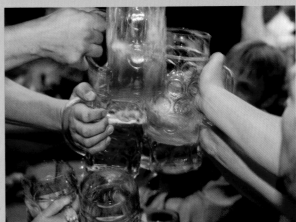

In the past five-legged calves, Siamese twins and women with no lower half pulled the crowds; today the big attractions of the Oktoberfest are much more high-tech, with dizzy, loud and stomach-churning rides the order of the day. For the more sedate there is still the old-fashioned merry-go-round, popular with young and old.

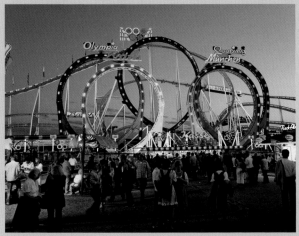

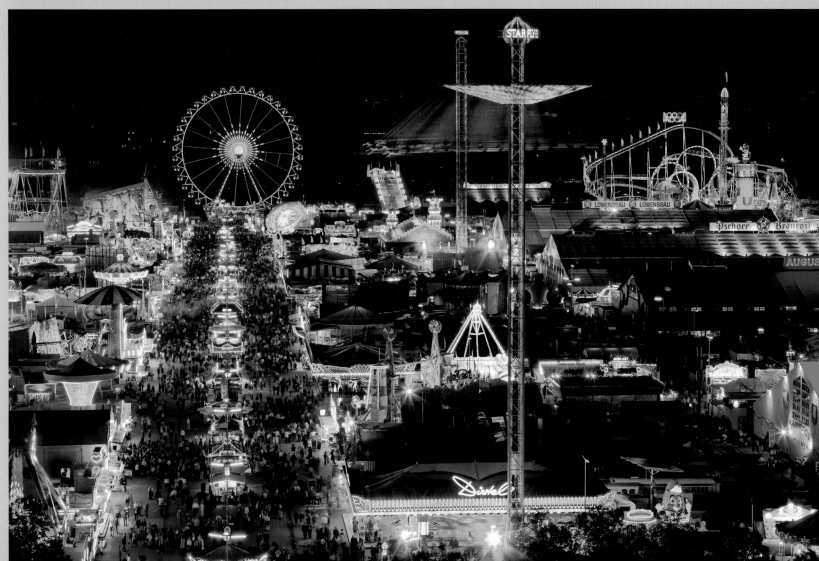

# OKTOBERFEST AND MORE –
# BAVARIA IS BEER COUNTRY

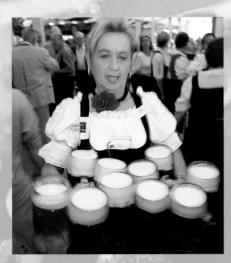

*Above and below:*
**Rushing to and fro for hours at a time with heavy tankards, like here at the Dachau Folk Festival, is part of the tough job of the waitresses.**

*Centre:*
**They are still called beer tents, but the gigantic structures set up for the Munich Oktoberfest today have very little in common with a provisional canvas shelter.**

Admittedly, beer was not invented by Bavarians, but they have managed to link it to their existence for posterity. The state not only can call the "world's first brewery" – Weihenstephan – its own, but also claims two dukes who earned special merit for the drinkable beverage. In 1516, Wilhelm IV and his brother Ludwig X decreed that memorable "Reinheitsgebot" or Purity Law, according to which beer may contain nothing besides water, barley malt and hops. Since the Bavarians wish to leave nothing to fate in this respect, they cultivate a top hop, according to the motto "only the very best ingredients for the best beer" in a hilly landscape called Hallertau between Ingolstadt and Munich.

It's not surprising then, that the beer god Gambrinus has favourite spots all over Bavaria. In Upper Bavaria, these are chiefly the famous Andechs monastery brewery and the state capital itself. There, the Oktoberfest has been held ever since 1810, drawing millions of people from around the world every year to the Theresien Meadows. A ride on the super roller coaster and other high-tech endeavours makes you hungry and thirsty, which is why countless amounts of "Weisswurst", "Hendl", "Steckerlfisch" and "Kalbshaxe" are gobbled up and washed down with even more extra strong and extra pricey beer.

Both the underestimation of this beverage and the overestimation of one's own steadfastness, however, quite frequently provoke consequences. For instance, in 1928 the American author

Thomas Wolfe – after putting away about 15 pints – got into a fistfight that yielded him a concussion, four head wounds and a broken nose.

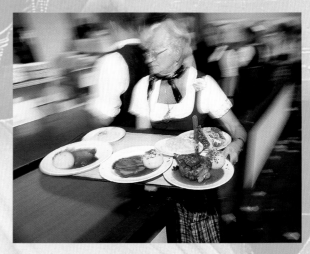

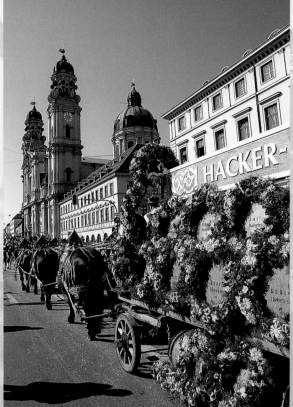

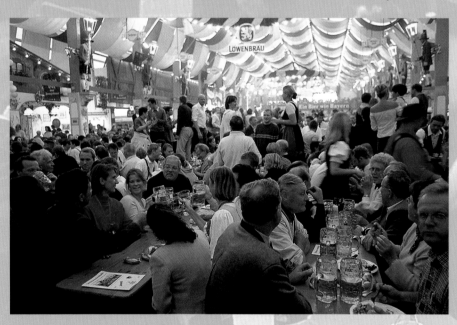

## COMFY COLOSSAL STRUCTURES

They're still called tents, but the Oktoberfest has long been housed in comfortable colossal structures that no longer have much in common with their name. Considering such superlatives, naturally, the waitresses must keep up. Rushing back and forth for hours on end carrying ten heavy beer tankards is also part of the reality of Oktoberfest today. Hard to imagine what would have happened if in 1910 the "German Alliance of Teetotallers" had gotten their way and forbidden women this profession for the sake

of morality! Although Munich likes to think it's the beer capital, it has strong competition. The region between Bamberg, Bayreuth and Kulmbach boasts the world's highest density of breweries. Wherever so much beer is brewed and drunk, it needs to get back out again. This was the logical conclusion faced by Jean Paul, one of the most highly-read authors in Goethe's day, when he was spotted letting water in public after a pub crawl in Bayreuth and had to pay not only the tax on the price of beer, but also a fine for unseemly waste disposal.

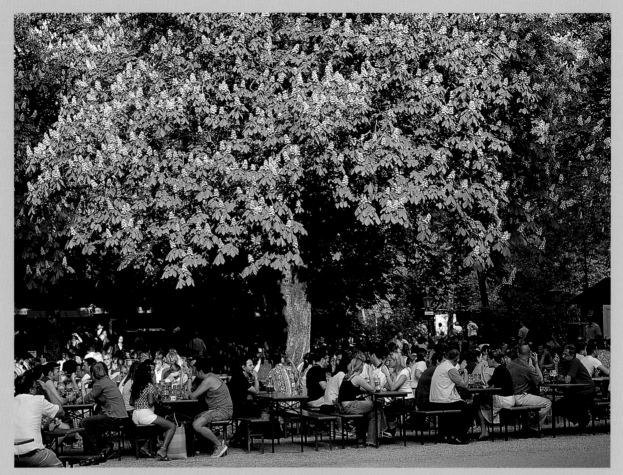

The people of Munich and their many guests from around the world agree that the beer garden situated at the Chinese Tower of the English Garden is one of the city's loveliest – and most beautiful while the chestnuts are in full bloom.

Munich's English Garden stretches along the Isar over an area of 350 hectares (865 acres). No other major European city boasts such a large and centrally located "green lung" with a large variety of leisure and recreational opportunities.

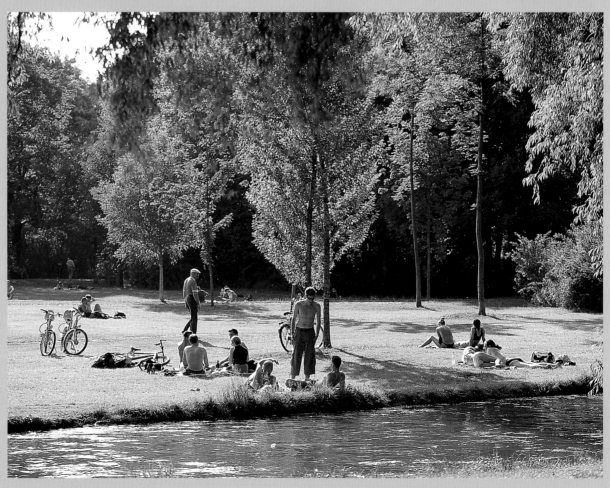

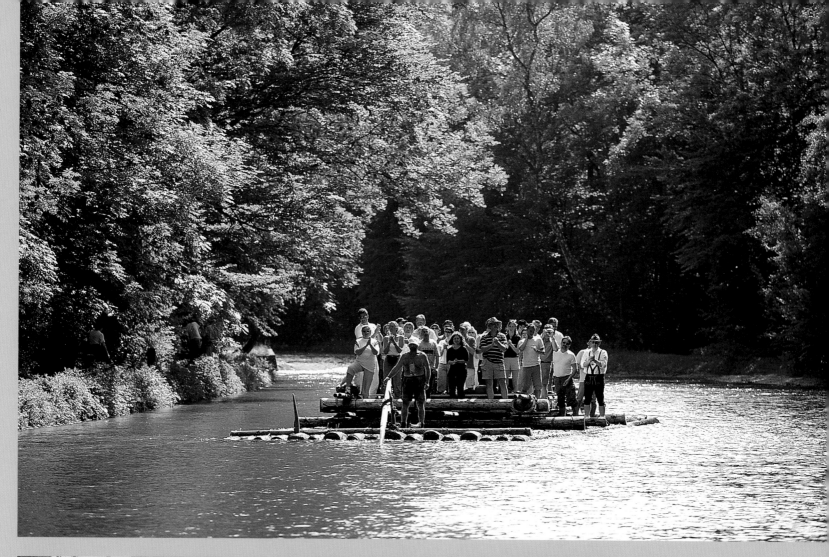

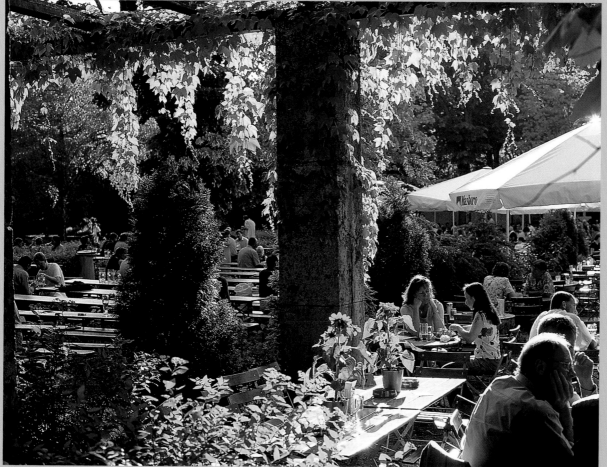

*Above:*
A cruise on the Isar River can be a jolly event! At one time, the rafts carried valuable goods like marble, lime, gypsum or wine. Today, they are reserved for the tourists, who have discovered the delights of this tranquil and inevitably damp mode of transport on the river.

*Left:*
Parkcafé on Munich's Sophien-strasse at the old Botanical Gardens. The new gardens were laid out between 1909 and 1914 in the north of Nymphen-burg Park – the western section of the Bavarian capital.

41

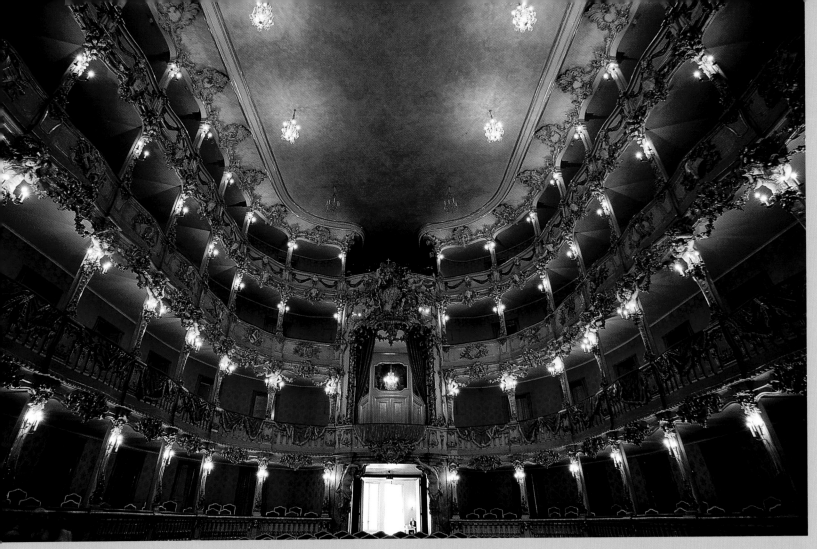

*Above:*
The Alte Residenztheater in Munich was erected in the mid-18th century by François de Cuvilliés. Before advancing to become the most significant architect of the southern German Rococo, he earned his living as the court dwarf of Elector Max II Emanuel.

*Right:*
The Deutsche Museum in Munich boasts one of the world's largest technical and scientific exhibits of its kind. Among the fascinating collections is a section for musical instruments.

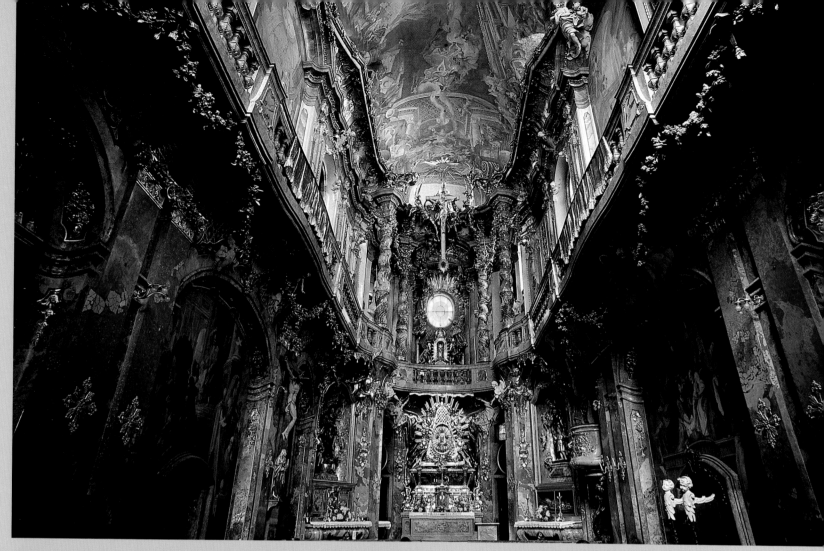

*Above:*
Of the many Baroque churches the brothers Cosmas Damian and Egid Quirin Asam designed and built, the opulent edifice on Sendlinger Strasse that bears their name is the most famous.

*Far left:*
The newest major museum in Munich is the Modern Pinako-thek, which has been exhibiting fine and applied art of the 20th and 21st centuries since 2002.

*Left:*
Bertold Brecht said of Karl Valentin that he "doesn't tell jokes ... he is a joke." A highly interesting museum was dedicated to the popular Munich actor and humorist in the southern tower of the Isar Gate, which also keeps the memory of his colleague Lisl Karlstadt alive.

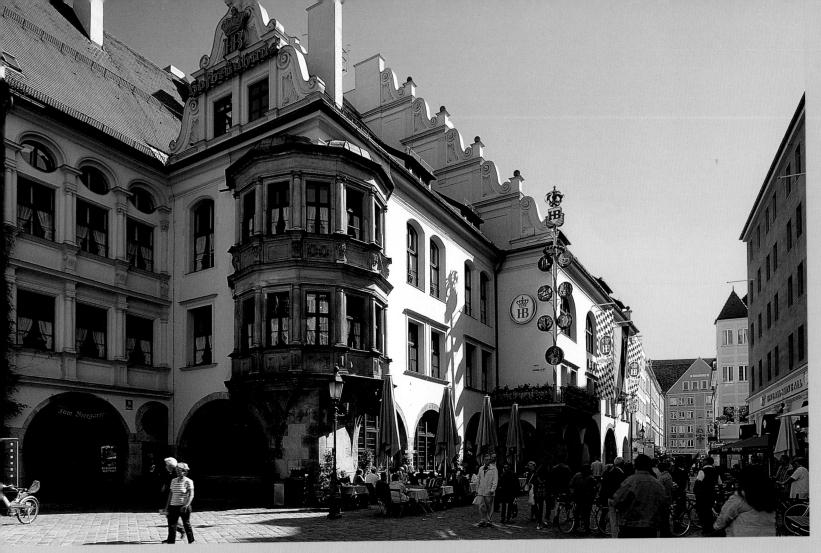

*Above:*
Even tourists sing along to "In München steht ein Hofbräuhaus ..." a song that is as well known as the beer the tavern serves. The 2,500 seats of one of the city's greatest attractions are often not enough for the crowds.

*Right:*
Even though much has changed here, Munich's Viktualienmarkt still has some of those characters long thought extinct. At "Fasching", the market women perform their traditional dance.

*Left:*
The Marienplatz was Munich's birthplace. A number of important trade routes once crossed it and it was the location of the salt and grain market. Hence, it is also the setting of the festival celebrating the city's founding, at which folklore is given its due respect.

*Below:*
If the Munich Hofbräuhaus with its 1,000 seats is too full or too loud for you, its courtyard with the lion fountain is a real alternative. A tankard of beer tastes just as good here.

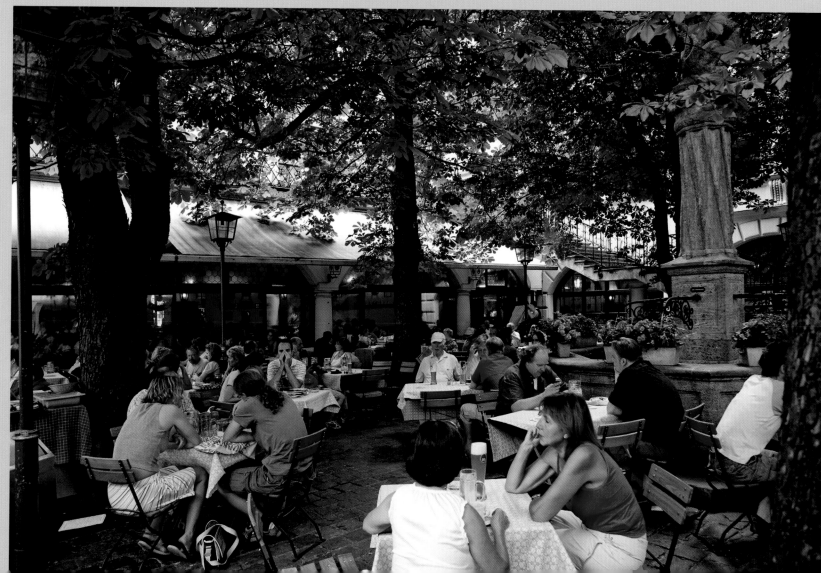

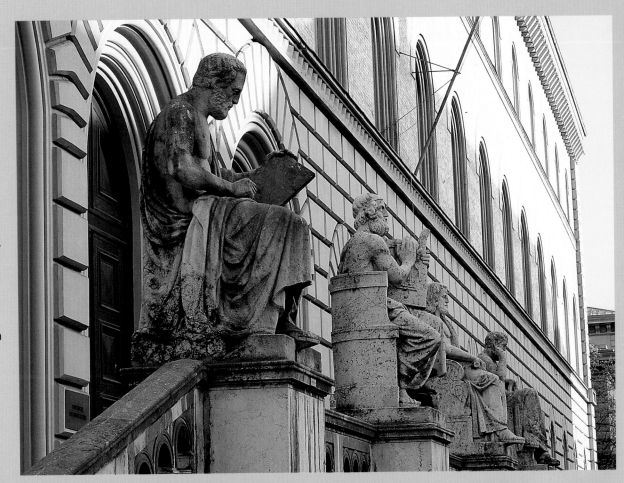

*Right:*
The stairway built by Friedrich von Gärtner for the Bavarian State Library (1832–1843) is flanked by four monumental seated figures of Thucydides, Homer, Aristotle and Hippocrates. The modern replicas were modelled after the originals by Ludwig von Schwanthaler.

*Below:*
The Glyptothek at the northern side of the Königsplatz was built between 1816 and 1830 by Leo von Klenze. It is the Bavarian capital's oldest museum as well as housing one of the largest collections of ancient sculptures in all of Europe, which were accumulated by King Ludwig I.

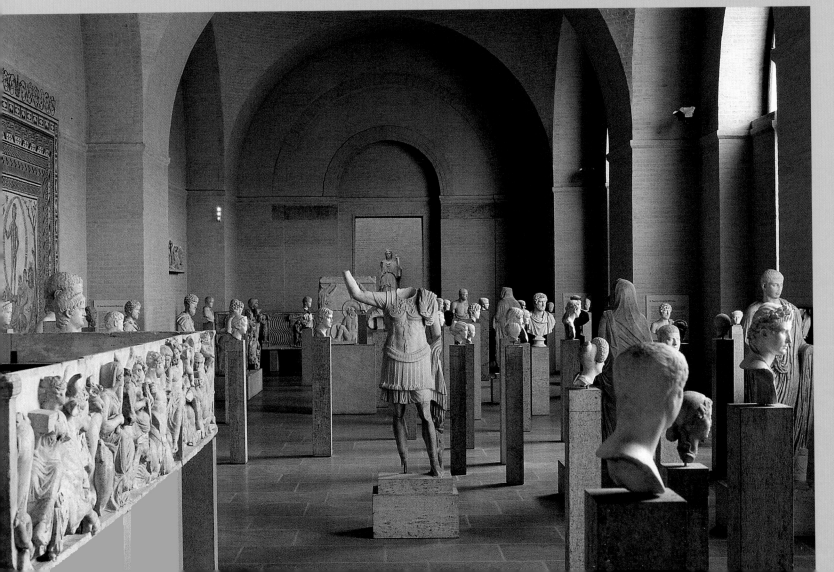

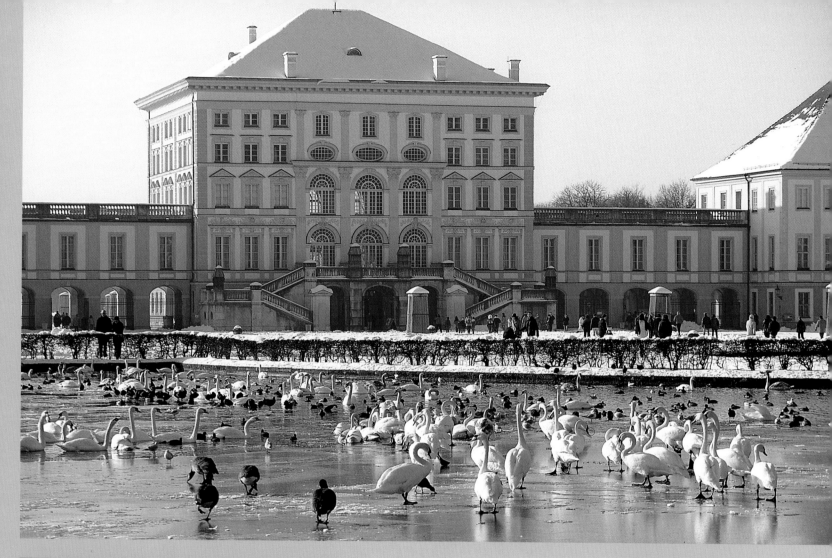

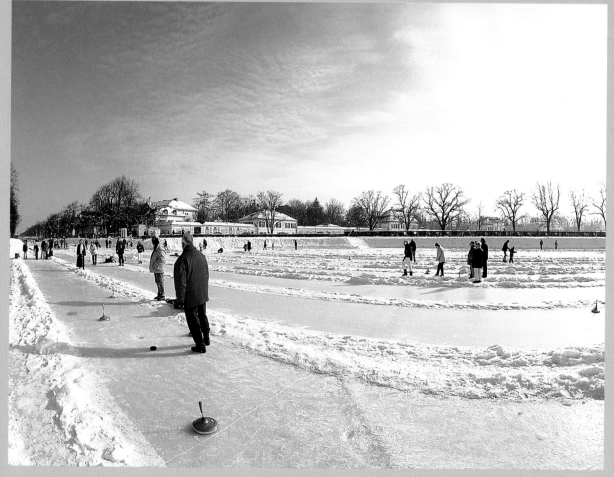

*Above:*
Electress Henriette Adelaide of Savoy began construction of Nymphenburg Palace. Work was ceased after her death in 1676 until Elector Max Emanuel had it continued. The central main pavilion and the two smaller annexed pavilions are connected to one another by galleries set upon arcades.

*Left:*
The Nymphenburg Palace Gardens began in Italian style, to later be French while today's English Garden-style appearance dates from the 19th century. The grounds are even appealing in winter, when the frozen lake serves for ice stick shooting (Bavarian curling).

# THE CITY OF THE "BLAUE REITER" –
# MUNICH

**Below:**
**Franz Marc's "Tiger". In his animal paintings, the artist reflected "the paradisiacal purity of animated creatures" (A. Schenck).**

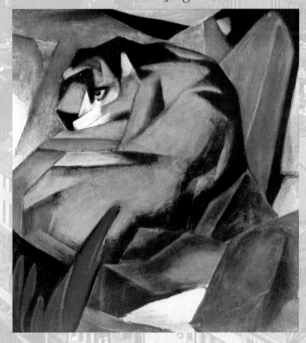

**Centre:**
**In the year 1913, Franz Marc painted "Die Weltenkuh". Today, the picture is owned by the Museum of Modern Art in New York.**

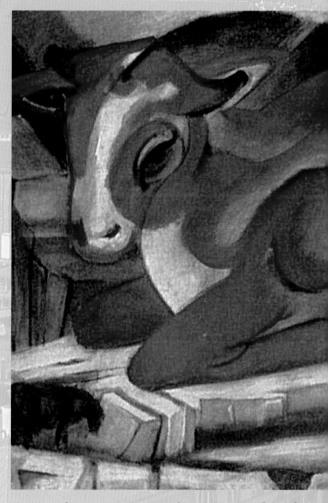

Surely not every Wittelsbach duke and king was aware of the benefits of art and artists, but they put their talents to good use in shaping the features of many a castle, church and city. The city to profit the most from this tendency to flaunt is the state capital of Munich.

Jörg von Halsbach was the first important master builder whose legacy lives on with the "Frauenkirche" (Church of Our Lady) constructed in the second half of the 15th century. The choir stalls of the church were created by Erasmus Grasser, who also collaborated with Halsbach on the "Alte Rathaus" (Old Town Hall) and carved the famous Morisco Dancers. While names such as Giovanni Antonio Viscardi, Enrico Zucalli, François Cuvilliés the Elder, Josef Effner, Leo von Klenze and Gabriel von Seidl have gone down in the great history of Munich's architecture, Hans Krumpper, the Asam brothers, Johann Baptist Zimmermann, Johann Baptist Straub and Franz von Lenbach put their mark on the city as painters, carvers or stuccoists.

## STIMULI FOR MODERN PAINTING

Art experienced a particularly golden age in Bavaria's metropolis under the regency of Prince Regent Luitpold (1886–1912). Not only did German literature receive decisive stimuli with Stefan George, Rainer Maria Rilke and Thomas Mann, but modern painting as well. The magazine "Die Jugend", the first issue of which appeared in 1896, lent an entire style its name: Jugendstil. In 1909, the "Neue Künstlervereinigung" was founded in the same city, with members such as Wassily Kandinsky, who would paint his first abstract watercolour a year later. Different opinions concerning the third exhibition of the "Neue Künstlervereinigung" led to fission in the group in 1911 and to the birth of a new one: the "Blaue Reiter" (Blue Rider). Its parents – besides Kandinsky – were Gabriele Münter and Franz Marc.

*Right:*
**After the death of King Ludwig II, the arts in Munich experienced another flowering under the rule of Price Regent Luitpold of Bavaria (1886–1912).**

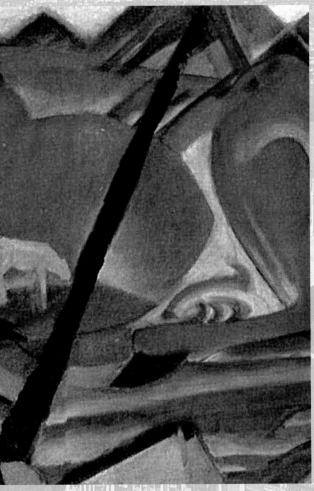

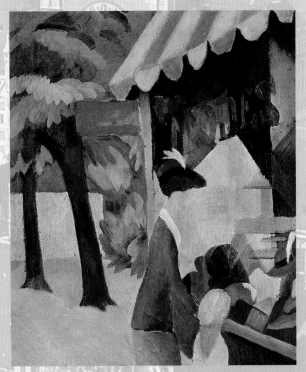

*Above Centre:*
**Leo von Klenze, court architect to King Ludwig I from 1816, was one of the most significant neo-classicist architects in Germany – along with Karl Friedrich Schinkel.**

*Above:*
**Wilhelm von Kaulbach (1805–1874) made a name for himself primarily as the creator of large-scale historical paintings as well as with book illustration.**

*Left:*
**August Macke was born in 1887 and fell on the battle-field in Champagne in 1914. The painting "The Hat Shop" dates from 1913.**

They were later joined by Marianne von Werefkin, Heinrich Campendonk, August Macke, Alexej von Jawlensky and Paul Klee. They held their first exhibition in 1911/12 at the Thannhauser art gallery and the second at Kunsthandlung Goltz. Although the group dissolved shortly after the beginning of the First World War, its existence, its pictures and its theories are crucially significant for modern painting.

The only native of Munich among the compatriots, who were linked by their mutual spiritual attitude but not by artistic style, was Franz Marc. Born in 1860, he first studied at the academy of his home city. Following study travels to Italy, Paris and Mount Athos, he moved to the countryside and began to paint in colours that no longer reflected the colours of nature, but his own reality. He began to discover shapes that broke with pure vision and pursued a new, cubist way of seeing. Particularly enthused by folk art, he profoundly absorbed the pictures and colours of his new surroundings and became ever more certain of his realization that "Art … in its essence" is "… the most daring distance from nature."

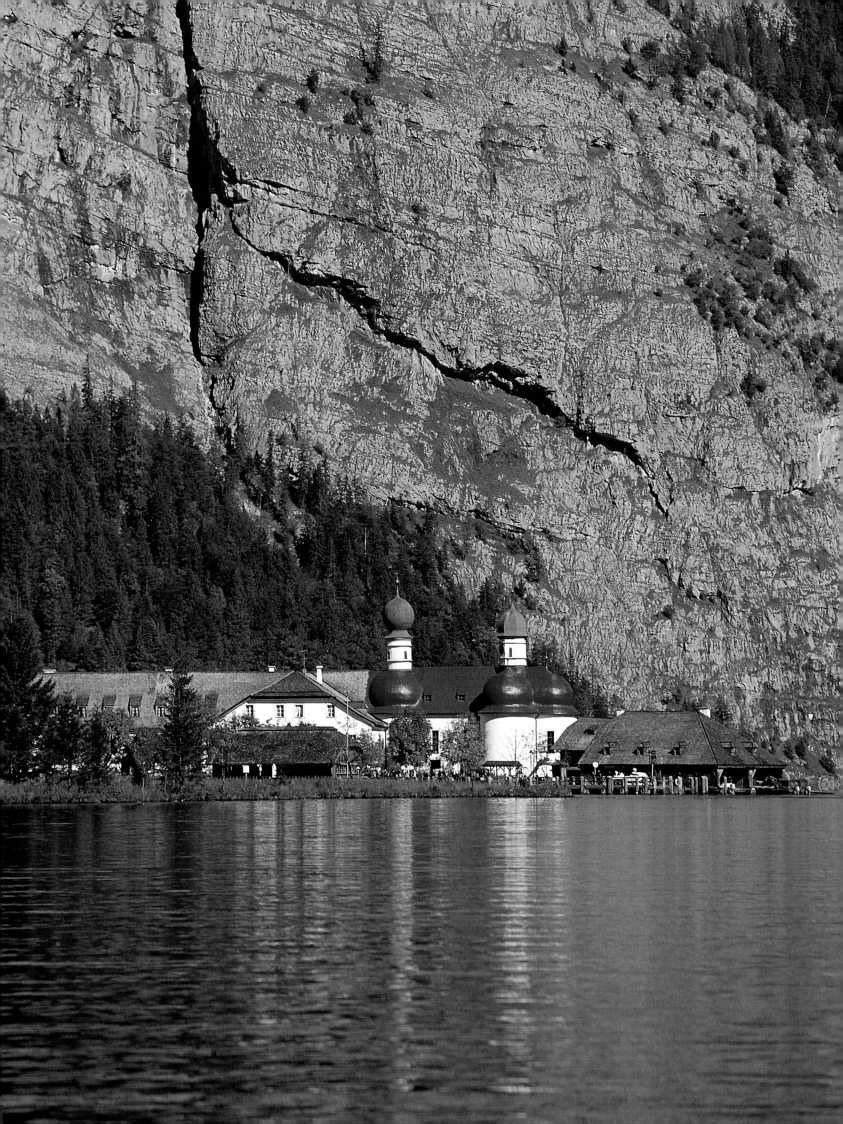

*Left-hand page:*
The Wendelstein famed for its views is connected to civilization by a ten kilometre long rack railway. The last section before the end station is the Schwaigerwand crowned by the Wendelstein chapel. The tiny church situated at a dizzy height was built in 1889.

Behind Münsing, the Zugspitze shows itself in glowing snow white. Here, on Germany's highest mountain, one can come 2,963 metres (9,729 feet) closer to the – sometimes – white and blue heavens. The first to put his feet on the summit was the Bavarian Lieutenant Karl Naus in 1820.

View from Wallberg in the Mangfall Mountains across the Rossstein and Buchstein to the Zugspitze. It appears inaccessible from afar, but it has been connected by four mountain railways (one on the Austrian side), which carry more than half a million people up every year.

55

*Below:*
Village idyll with a Baroque touch: Truchtlaching lies north of the Chiemsee on one of its feeding rivers, the Alz.

*Below:*
The Fraueninsel (literally: women's island) on the Chiemsee is one of Bavaria's most beautiful and culturally valuable places. The convent, whose first abbess, Irmengard, was the daughter of King Ludwig the German, has not only a great Carolingian gate hall, but also a fascinating garden.

*Right:*
The palace and the gardens of Herrenchiemsee are reminiscent of their great prototype, Versailles. The fountains have been back in operation for a few years now.

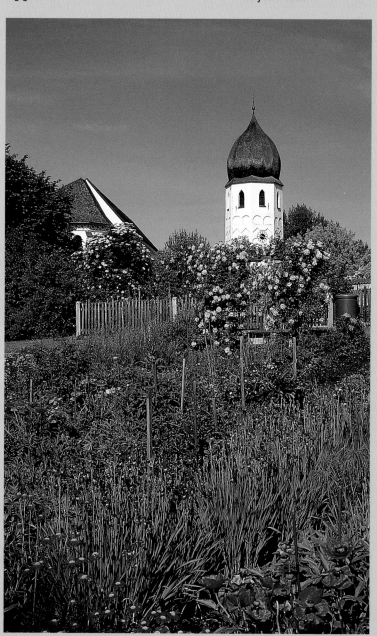

*Right:*
The hall of mirrors in Herrenchiemsee Palace was installed between 1879 and 1881. It is almost 100 metres (over 300 feet) long over the entire garden front side of the building, thus surpassing the original at Versailles.

56

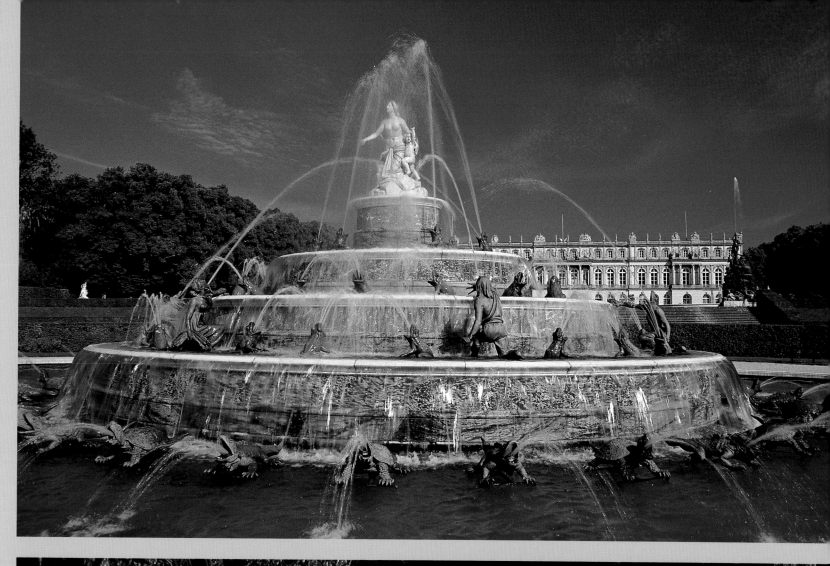

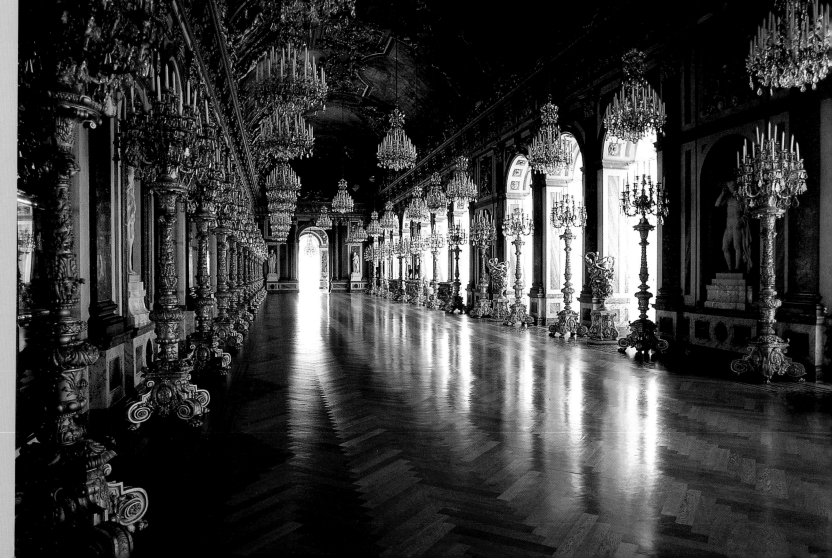

*Above:*
The River Isar separates the spa quarter of Bad Tölz from the town, which evolved from a tiny 12th-century fishing and shipbuilding settlement. The main thoroughfare is the Markt-strasse, with houses decorated with colourful sgraffito and stucco.

*Right:*
Rosenheim was first mentioned in documents in the year 1232 and was given market rights about one hundred years later. Bridging the Inn River, it profited from the salt trade. Max Josef Square is the centre of the town, flanked by lovely houses in the "Inn-Salzach style".

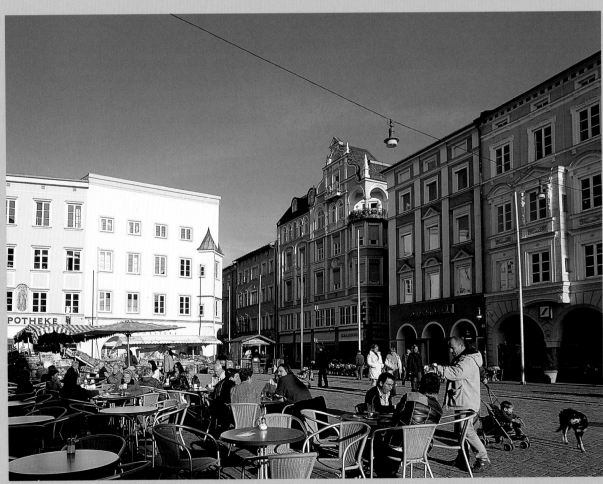

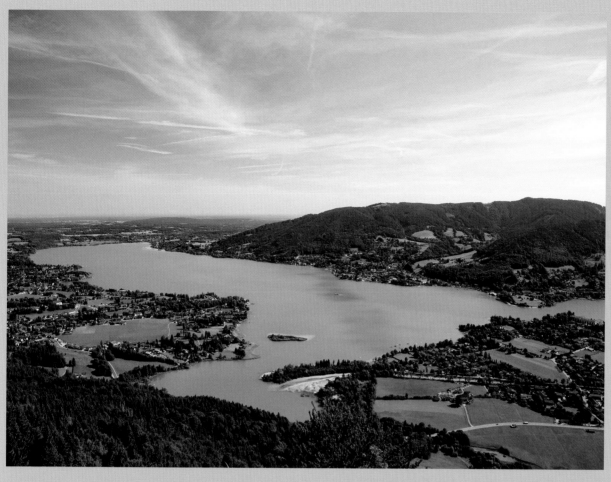

*Left:*
The Tegernsee enjoys a splendid setting in the Alpine foothills, just 50 kilometres (30 miles) from Munich. Famous spas and bathing resorts line its shores, among them Rottach-Egern (right) and Bad Wiessee (left).

*Below:*
View of the palace and the monastic church in Tegernsee. In the mid-11th century, a monk here wrote the first entirely fictional tale in German literature. The title character of the epic poem written in Latin interspersed with many German words is the knight "Ruodlieb".

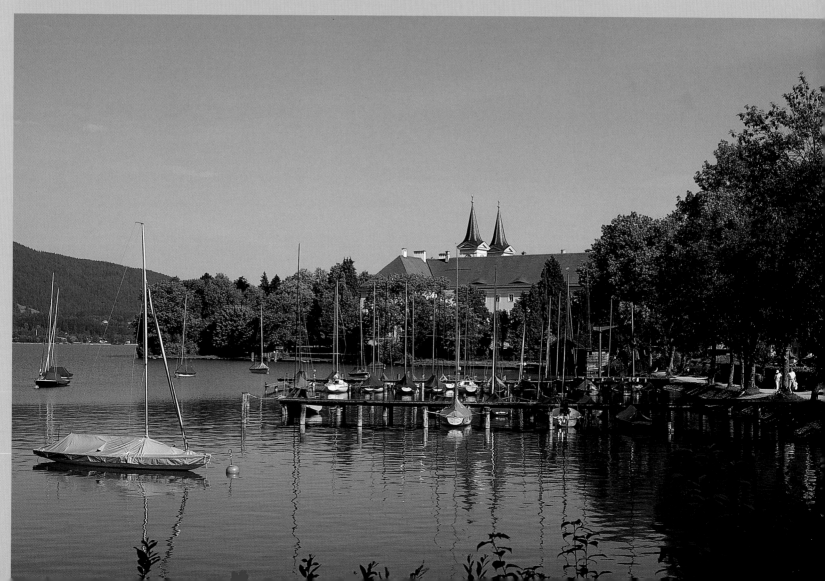

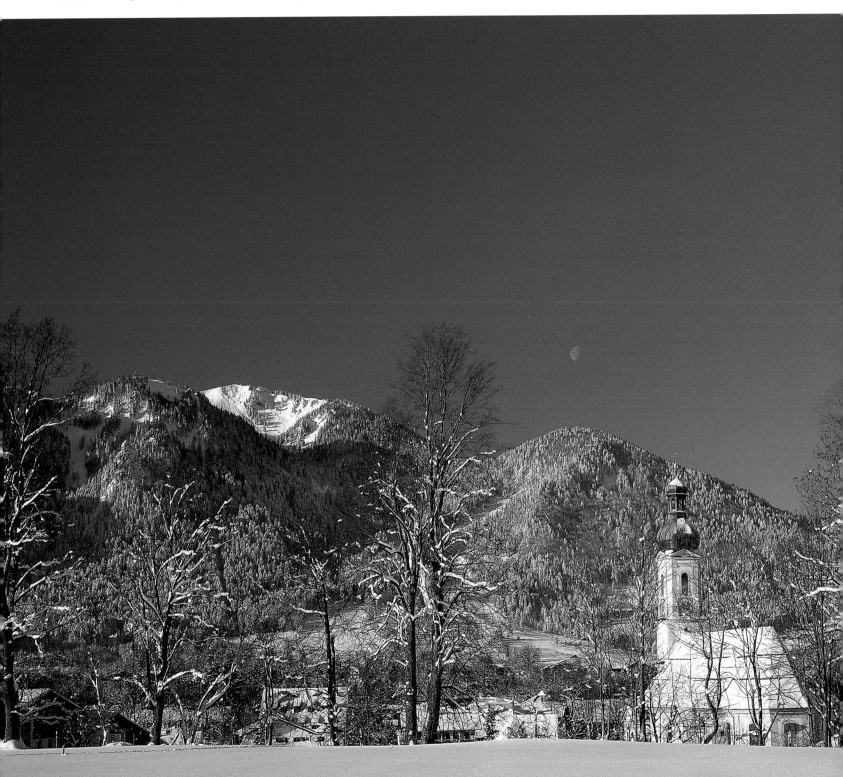

*Below:*
The municipality of Lenggries situated in the crook of the Isar River encompasses 50 villages spread over nearly 250 square kilometres (97 square miles).

In the background, we see the Brauneck, the home mountain of the popular spa and winter sport location, which can be reached by cableway.

*Small photos on the right:*
Every January in Gaissach, an unusual race is held that's great fun for both participants and spectators. Young men and women in their "Fasching" costumes zoom down the slope on their

horned sledges. Yet, the slope is so steep and so long, that mishaps – well, proper spills – can hardly be avoided.

The spectacle starts on the 1,500-metre (4,925-foot) high Schwaigeralm.

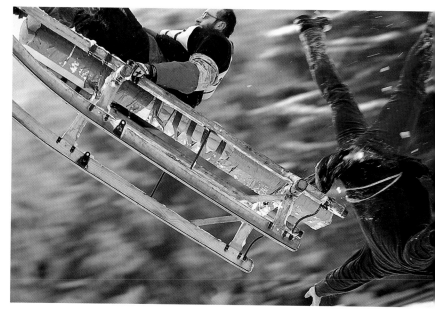

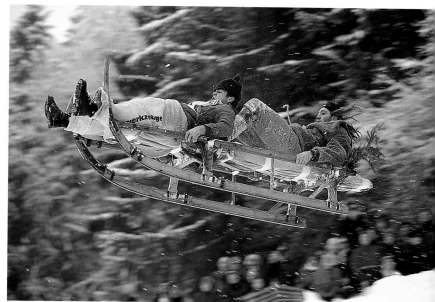

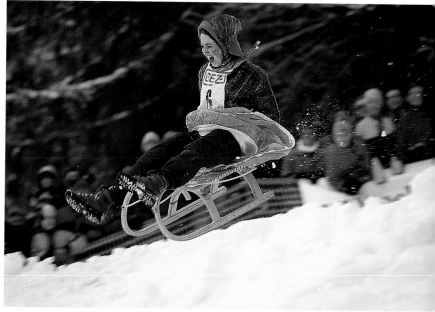

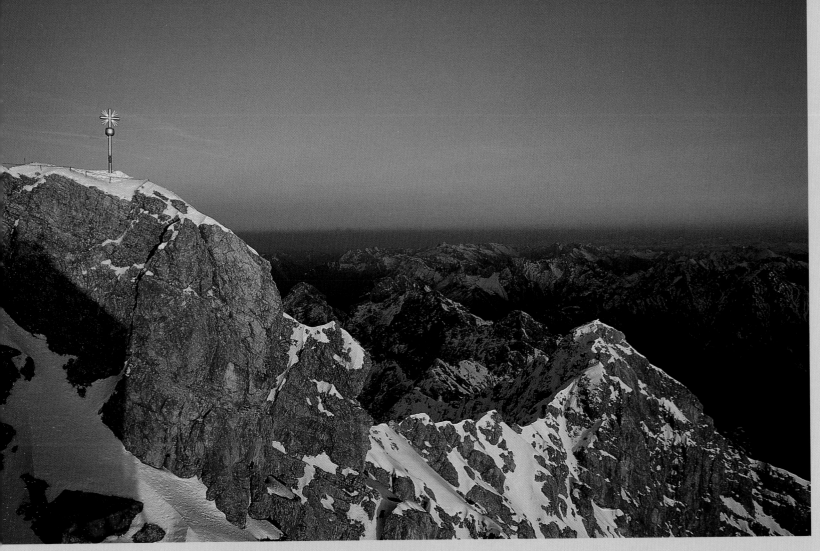

*Above:*
View east from the Zugspitze. The impression of lonely solitude is deluding: even bad weather cannot prevent the crowds. Up here even on rainy days, there are plenty of opportunities to keep busy – including a visit to the highest art gallery in Germany.

*Right:*
Winter on Kochelsee. The Loisach flows through the lake, which ends to the north in broad moors. The peaks of Heimgarten, Herzogstand and Jochberg provide the picturesque mountainous framework to the south.

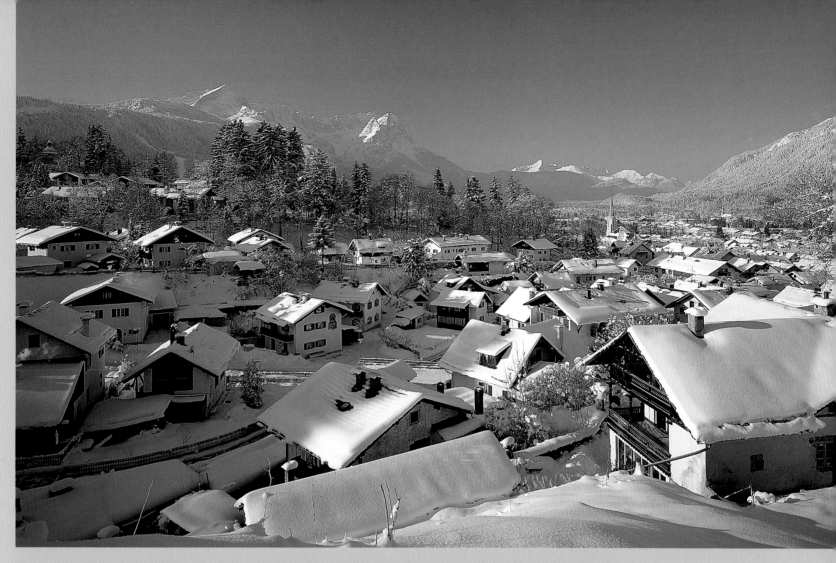

*Above:*
At the foot of the Wetterstein Mountains, Garmisch and Partenkirchen were combined to one market town in 1935. Partenkirchen was already around as "Parthanum" in Roman times, while its sister city was first documented in 802. The backdrop: Alpspitze and Zugspitze.

*Left:*
The façade of the inn "Zum Husaren" in Garmisch-Partenkirchen is decorated with original sgraffito in Empire style. The tower in the background belongs to the old parish church of St Martin.

63

Not far from the Olympic stadium in Garmisch-Partenkirchen, the Partnach ravine carves its way through the mountainside. Walking the

wildly romantic gorge is risky, as the 1991 rock fall that closed it off proved. It was not opened to the public for another year.

If you hike two and a half hours from the popular holiday town of Grainau at the foot of the Zugspitze you may reach the Höllentalklamm (literally: hell's valley ravine). The pathway to the 1,387-metre (4,554-foot) high Höllental green lodge leads over bridges, through tunnels and past this waterfall.

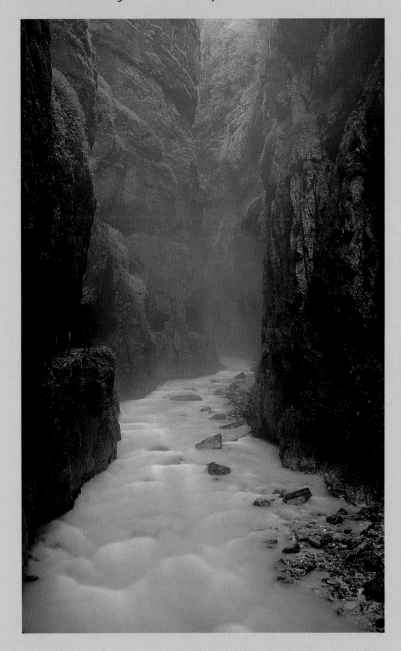

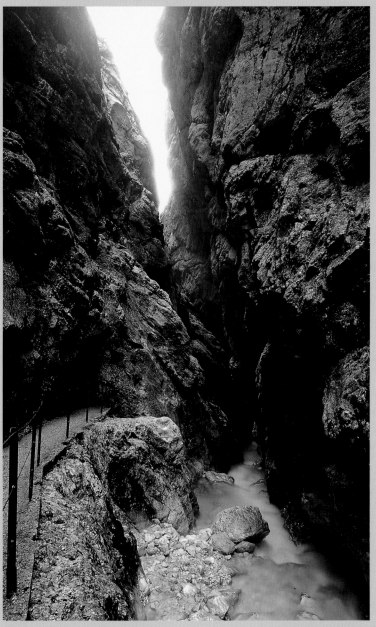

There is a lovely path from Mittenwald to the Leutasch ravine and further to the inn "Am Gletscherschliff" where one can view the largest site of Ice Age glacier abrasion in the northern limestone Alps.

This picturesque waterfall is near the village of Jachenau, which gave the entire valley its name from the Walchensee in the west to Lenggries in the east.

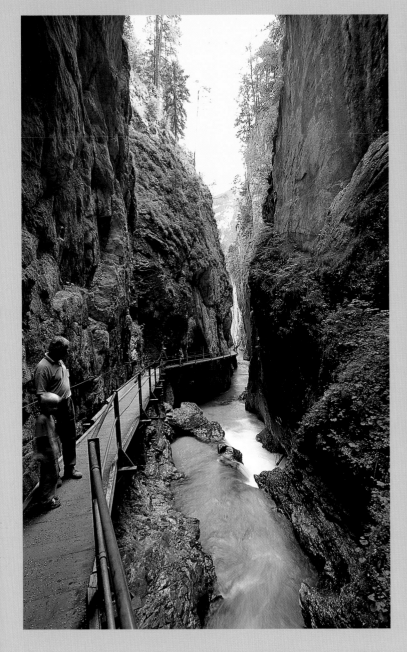

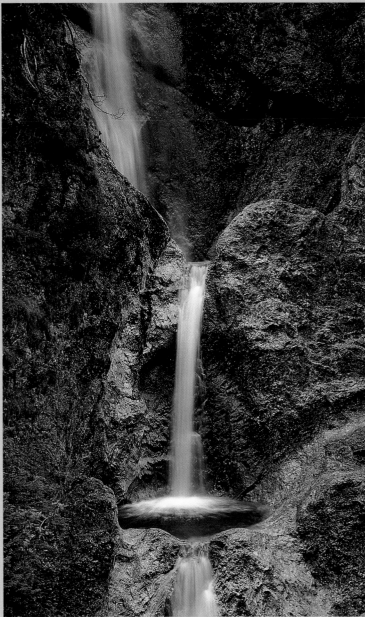

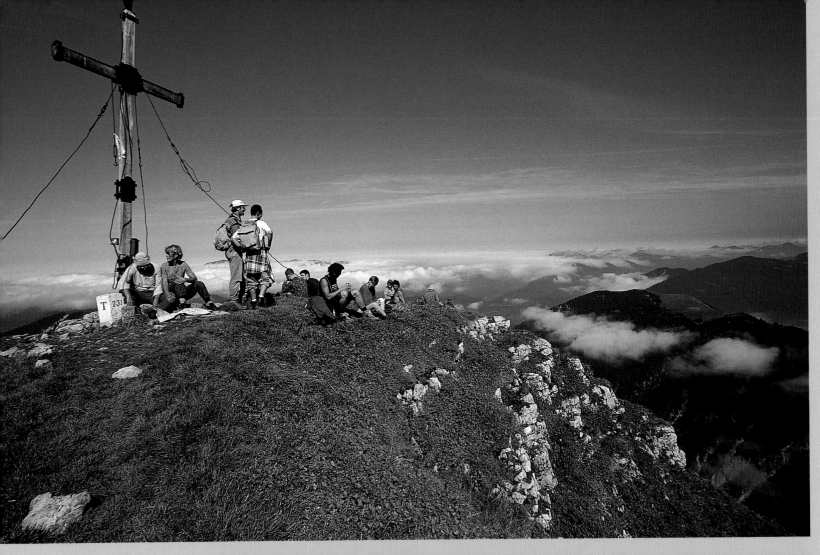

*Above:*
On the summit of the Schafreuter in the Karwendel Mountains. The mountains of grey limestone are very craggy and characterized by huge heaps of rubble and powerful rock walls. However, different from other massifs, they do not possess the prominent pinnacle shapes.

*Right:*
As almost everywhere in Alpine regions, the best pastureland is reserved for the cows, while the more undemanding sheep must make do with rougher meadows.

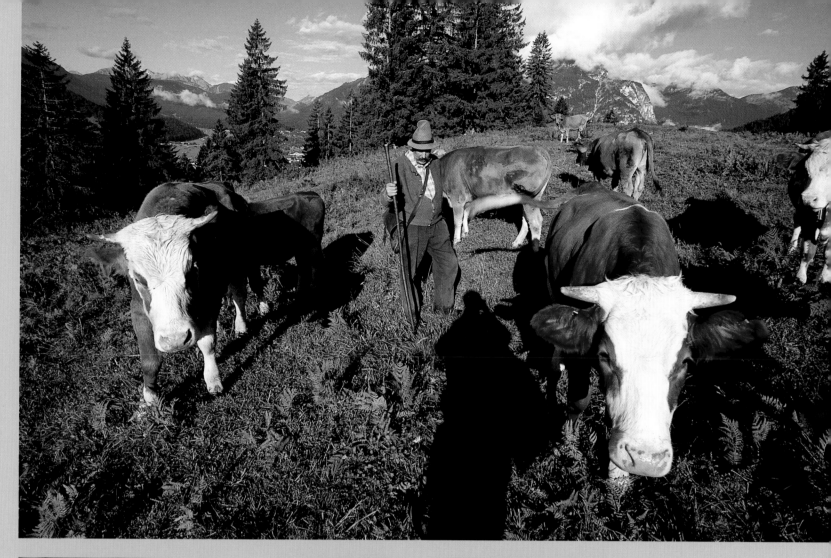

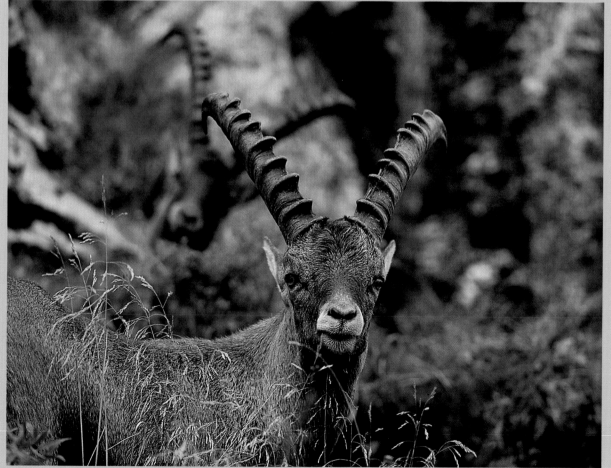

*Above:*
The life of the shepherds in the great outdoors has always been good stuff of legends. However, the work on the alpine pastures is everything but idyllic. Today, mobile phones help to bridge even the largest distances, but one must be born for this job.

*Left:*
An ibex at the Benediktenwand. After these animals were nearly driven to extinction, a few were released in the northern Karwendel Mountains. They feel so at home here that they are reproducing rapidly and are not even camera shy.

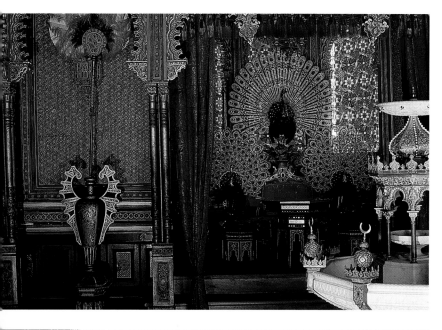

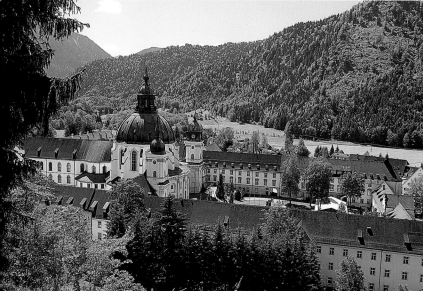

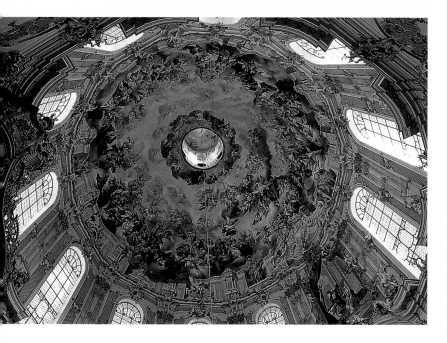

The Oriental Pavilion is one of the many follies scattered about the park at Schloss Linderhof. Initially created for the World Exhibition in Paris in 1850, the pavilion encapsulates the colour and form of the Arabic world, with the fantastic Peacock Throne as its centrepiece.

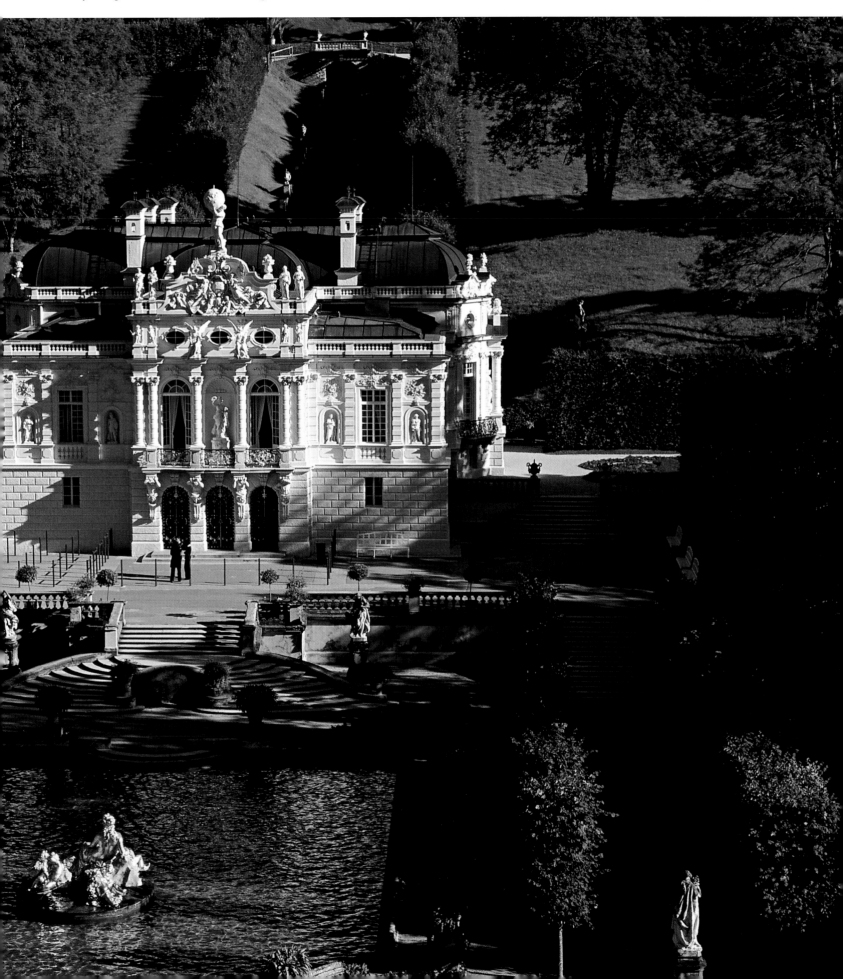

*Centre left:*
Ettal Monastery in the Ammergau Alps was the result of a vow taken by Emperor Ludwig the Bavarian. Founded in 1330, the later Baroque-style abbey church was closed in 1803 and partly destroyed due to secularization. The Benedictines were not able to return until around 100 years ago.

*Below left:*
Between 1710 and 1726, Enrico Zucalli from Graubünden converted the Gothic central part of the Ettal monastery church into a Baroque domed structure. Later, after a fire, Joseph Schmuzer from Wessobrunn gave it this Rococo garb around 1750.

*Below:*
Schloss Linderhof shows off in the fancy ornamentation of the Rococo, as well. Yet, when it was erected (1869–1878) that age had long past. Its resurrection here, in the Graswang valley, was due to King Ludwig II.

The town of Pähl in Pfaffen-
winkel has two tower-
guarded buildings. Caspar
Feichtmayr, the architect of
the monastery church in
Benediktbeuren, put the
Baroque onion cap on the
parish church of St Laurentius
about 1680, while the neo-
gothic castle was put up in
the late 19th century.

*Right:*
In 1976, Upper Bavaria's
Glentleiten open-air museum
far above the Kochelsee was
opened to the public. Tradi-
tional crafts are demonstrated
here – like this turner at his
lathe – and customs are
presented.

*Far right:*
If you are lucky, at Glentleiten
you can not only watch the
"Schmalznudeln" made of
yeast dough being fried, but
even have a taste when they
are finished.

*Far right:*
Weaving demonstration at
Glentleiten. The farmers and
the farmers' wives of olden
days had to master a number of
crafts. Almost every farmstead
had its own loom.

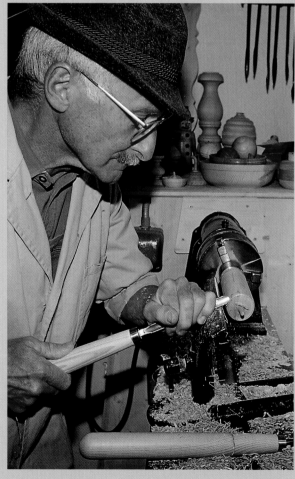

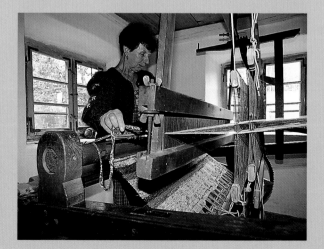

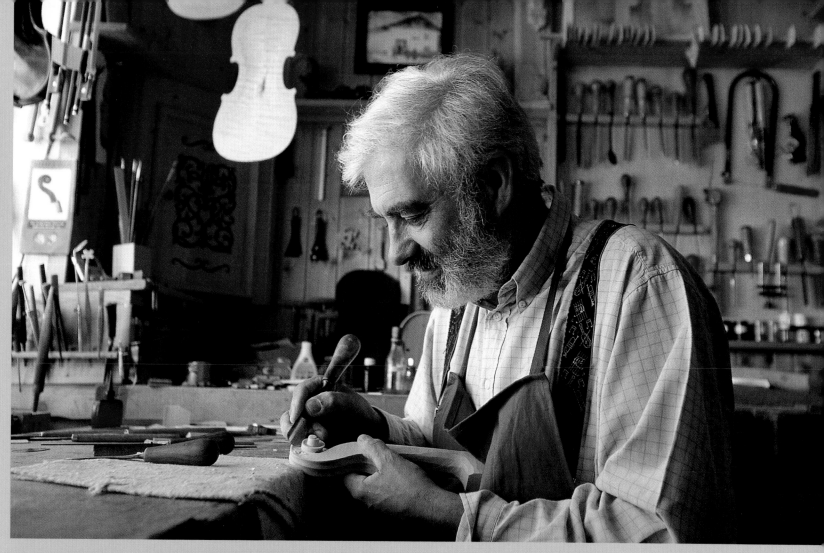

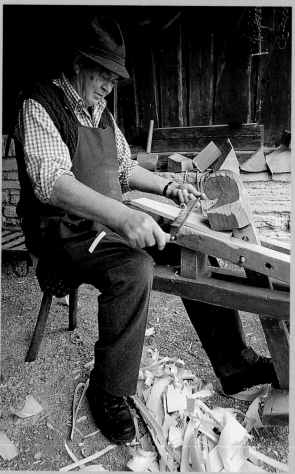

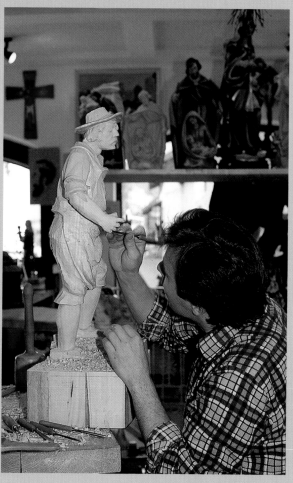

*Above:*
Master violinmaker Anton Maller from Mittenwald in his workshop. In this town, musical instruments have been built for more than 250 years.

*Far left:*
Not long ago, nearly all Upper Bavarian farmhouses were covered with shingles. At the museum in Glentleiten, Erwin Porer shows how they were made.

*Left:*
Oberammergau is not only world-famous for its passion play but also for its traditional woodcarvers. They originally produced their works for pilgrims to Ettal, and later for other clientele from near and far.

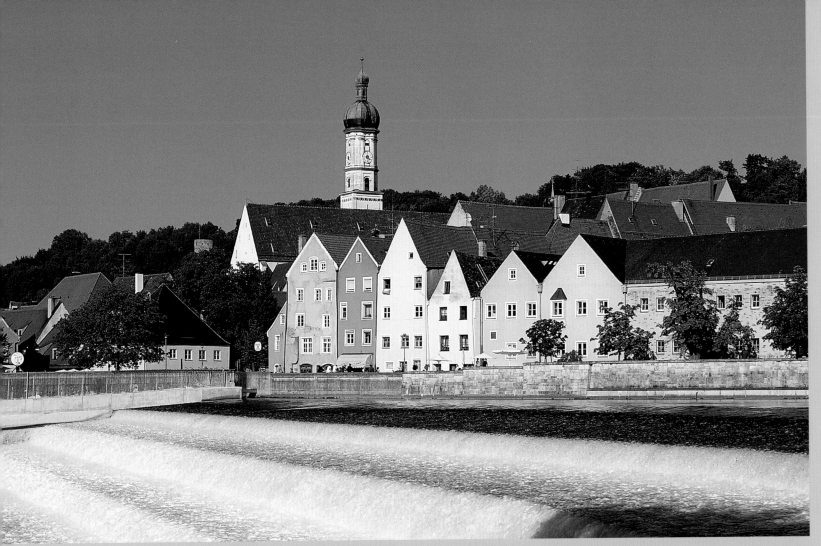

*Above:*
The city of Landsberg grew on a gravel embankment in the Lech at the feet of the castle erected by Henry the Lion in the mid-12th century. It owes its wealth to the salt route, or, more specifically, to the bridge that allowed traders to cross the river and therefore fill the town coffers.

*Right:*
Every four years at the end of July, Landsberg is the magnificent setting of the "Ruethenfest." At Bavaria's largest children's festival, over 1,000 actors re-enact historical events from the town's history.

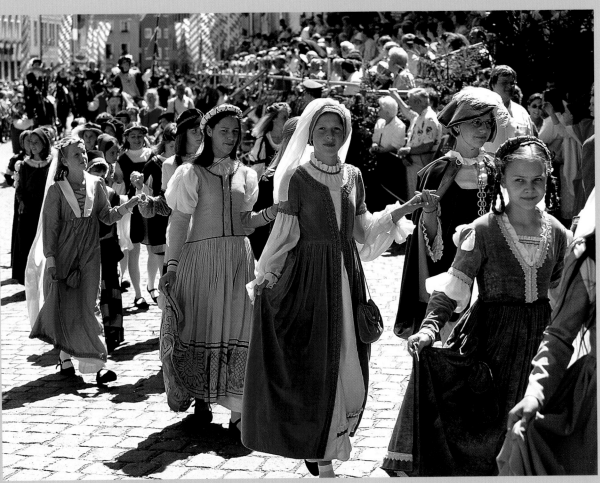

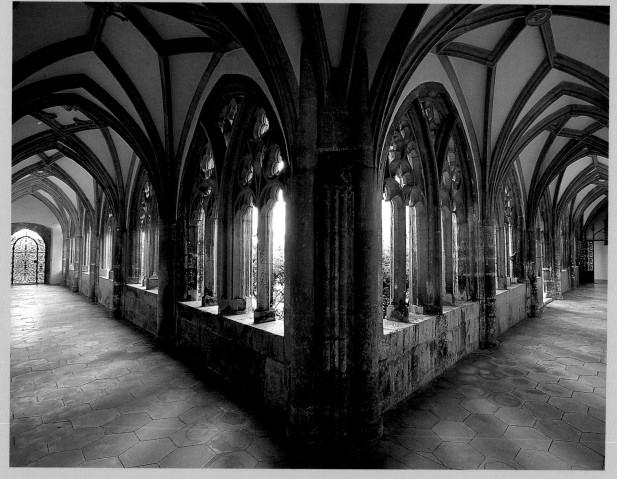

*Above:*
In Mariabrunn (Dachauer Land). It would take more than one lifetime to get acquainted with every Bavarian beer garden.

*Left:*
The beautiful cloister of the cathedral of "St Salvator, Our Lady and St Willibald" in Eichstätt was built in the Late Gothic period.

*Pages 78/79:*
Like from another world: a view from the Tegel mountain cableway to the mist-encircled castle of Neuschwanstein.

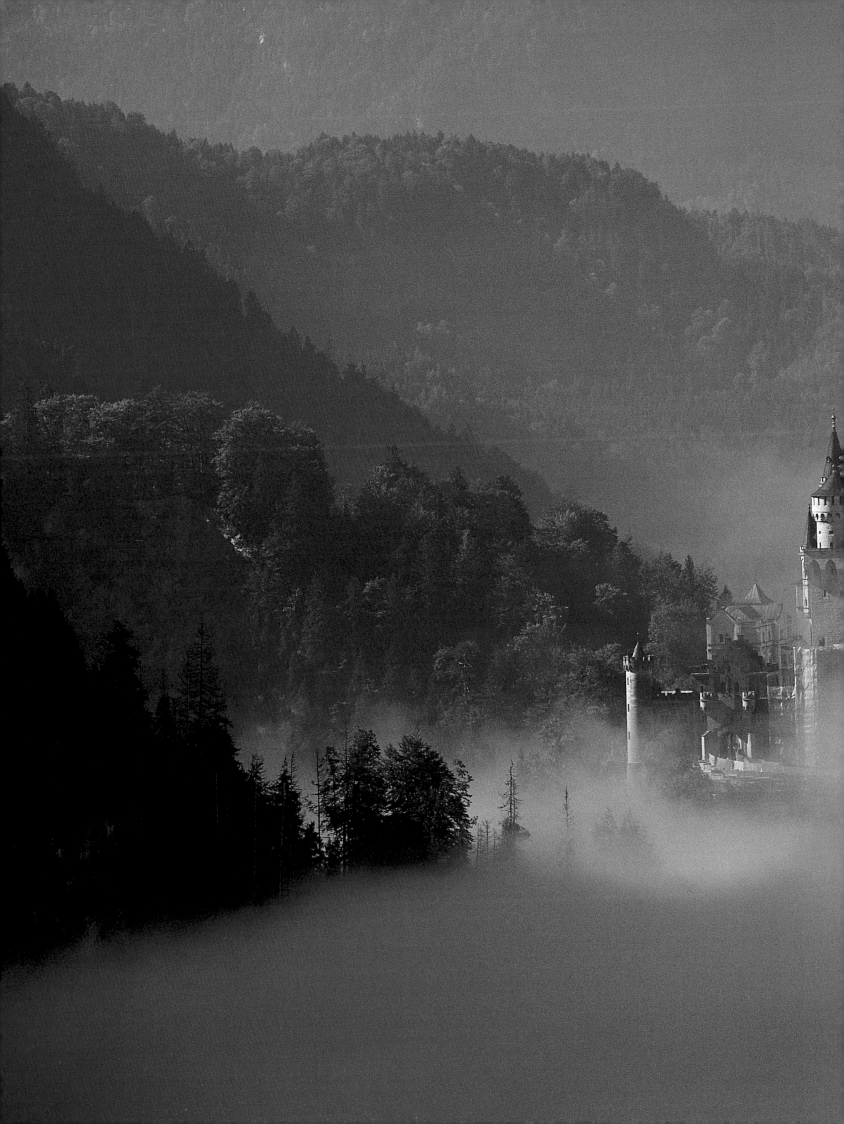

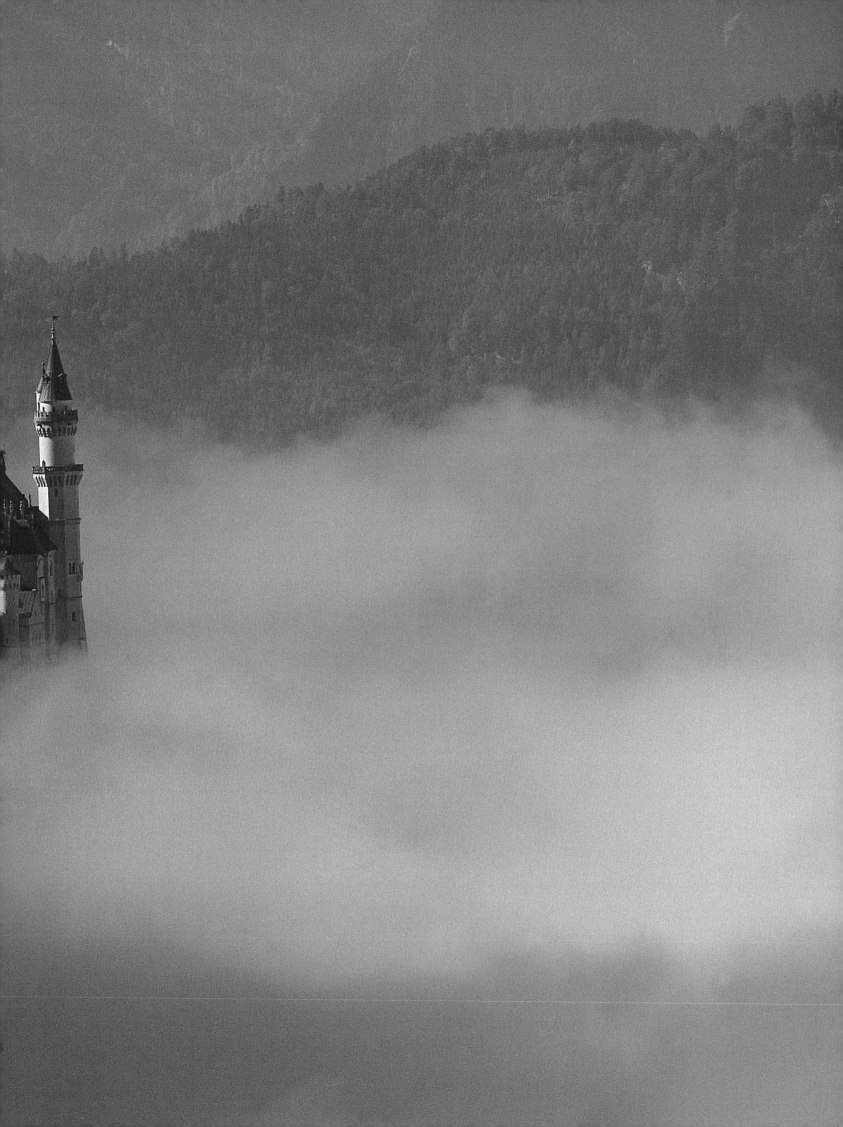

*Right:*
**This portrait by photographer Joseph Albert was taken in 1833 and is one of the last of Ludwig II.**

*Below:*
**The 1886 photograph shows the Byzantine-style throne room of Castle Neuschwanstein.**

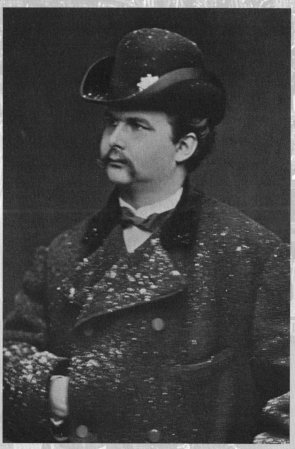

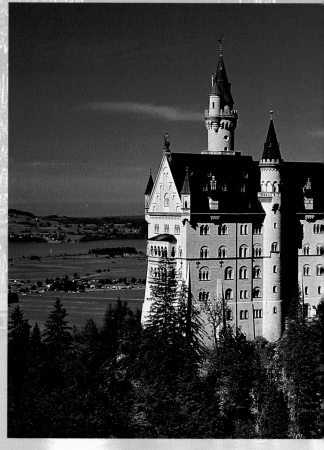

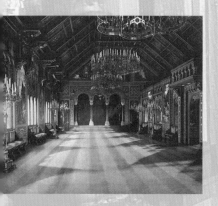

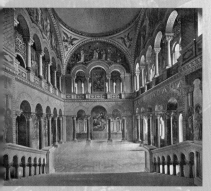

*Above:*
**The Sängersaal (singers' hall) at Castle Neuschwanstein refers to the legendary contest of the most famous minnesingers at Wartburg Castle.**

The skies were overcast on Whitsunday of 1886, when the king, who had a few days before been declared insane and confined to Schloss Berg on the Starnberger See, was taking an evening stroll accompanied by his psychiatrist Dr Gudden. It rained intermittently. Four hours later, their corpses were found on the lakeshore, where the water was as shallow as much of the talk that soon was spread by semi-official sources about the death of the monarch.

King Ludwig II of Bavaria, son of Crown Prince Maximilian of Bavaria and his Prussian princess wife, was born in 1845. Following the death of his father, Ludwig was made head of government at the tender age of 18. His endeavours were recognized by none other than the Prussian Imperial Chancellor Bismarck, who conceded that the king ruled "better than all his ministers" and made him a chief player in his empire game by giving Ludwig the task, as representative of the German princes, to offer the imperial crown to the King of Prussia. The fact that he refused to collaborate in the final act of this grotesque play and demonstratively shunned the coronation in Versailles, reveals how he detested the role given to him by the new world power. He shocked his court advisors with the order, "not to speak of politics until his Majesty asks".

These crass realities would probably have been the end of Ludwig if he hadn't found escape in another, fairy-tale world where he could be king as he saw fit. The Bavarian monarch was a great

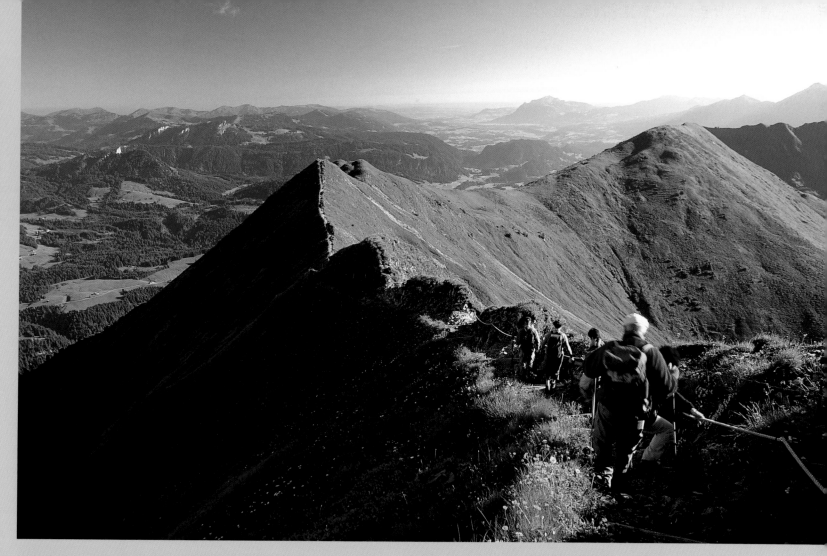

*Above:*
Allgäu appeals to both mountain hikers and climbing freaks. During some mountain tours, a number of ridges must be walked – as here on the Fellhorn summit.

*Left:*
Moosbach, part of the town of Sulzberg, is situated pictur-esquely on the Rottachsee southwest of Kempten. Nearby there is a large recreational park.

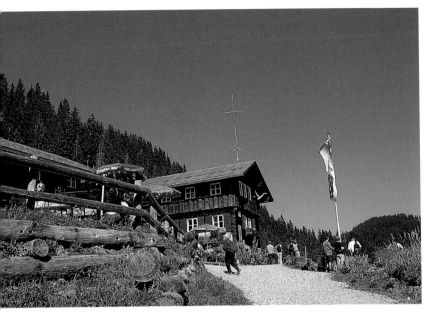

*Above left:*
Bolsterlang is the ideal starting point for a hike to the "Berghaus Schwaben" in the Allgäuer foothills.

*Centre left:*
Musicians from Heimertingen perform a concert on the 2,224-metre (7,302-foot) high Nebelhorn.

*Below left:*
Every year at Whitsun, a busy pilgrimage in traditional costume leads from Nesselwang to Maria Trost on the mountain.

*Below:*
The "Viehscheid" – or cattle sorting – in autumn is one of the important dates in the farming calendar in Allgäu, which is also interesting for visitors.

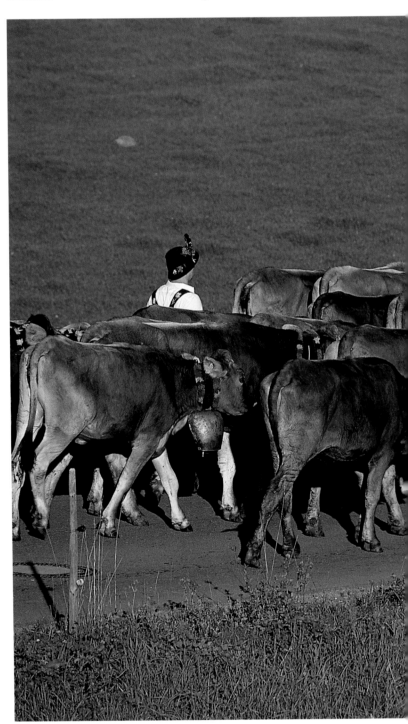

*Above right:*
The Nebelhorn is suitable not only for flying kites and for hang-gliding, but also for dancing, as the young people from the Walser costume group demonstrate.

*Below right:*
"Alm" near Gunzesried. Whether there is really no sin on the alpine pastures, as the lyrics to a song claim, is doubtful. What's certain is that the cattle are a lot of work.

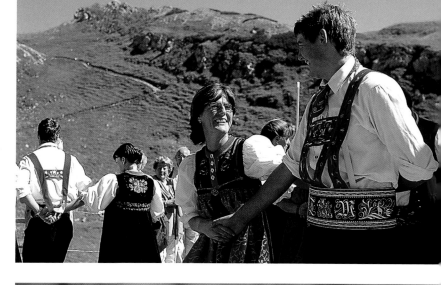

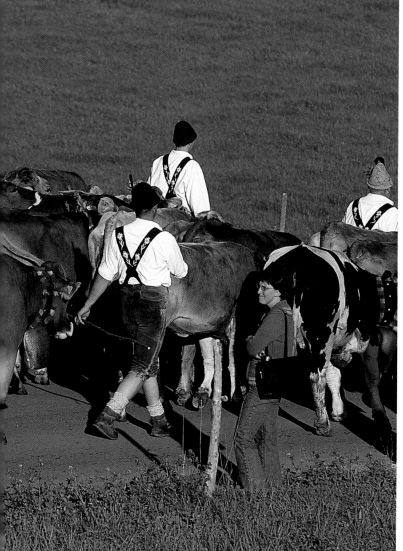

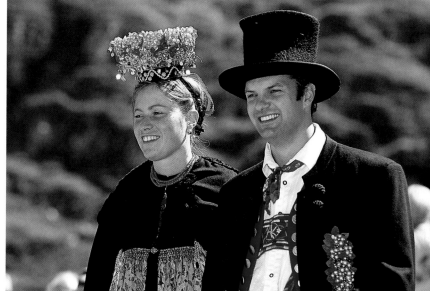

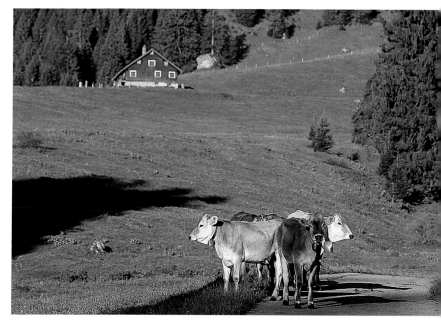

87

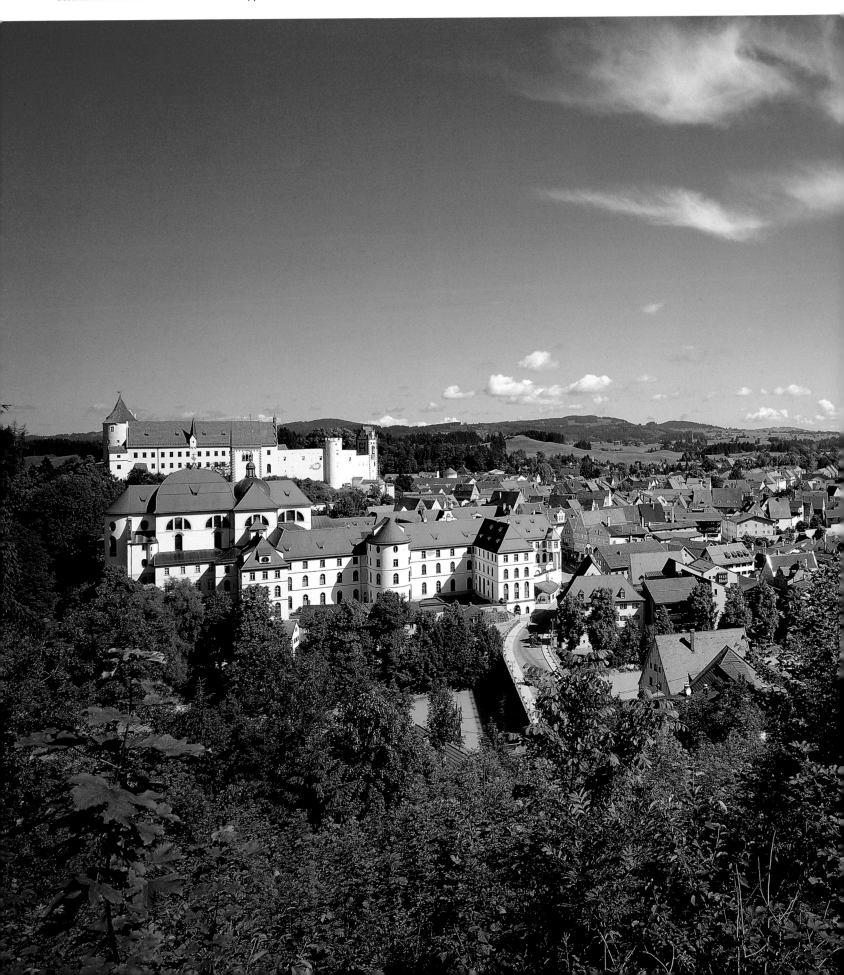

*Below:*
The city of Füssen lies approximately 800 metres (2,626 feet) above sea level and is not only known as a winter sport location, but is also a popular destination in the summer.

The surrounding mountains, the nearby castles of Neuschwanstein and Hohenschwangau and the Forggensee (right foreground) provide diverse recreational and leisure opportunities.

*Above right:*
Kempten, the largest city in the Allgäu, looks back at a rich history, which began with the Celts and Romans and continued as Free Imperial City and the days as a residence of a prince-abbot. The city hall dates from the year 1474.

*Centre right:*
Hindelang was mentioned in documents as early as the beginning of the 12th century. Surrounded by a number of over two thousand-metre (6,566 foot) mountains, the sport and spa town boasts Germany's highest sulphur springs.

*Below right:*
Although Oberstdorf was already one of the most popular Bavarian holiday destinations, in 2005 the town came to world fame with the World Championships in Nordic skiing.

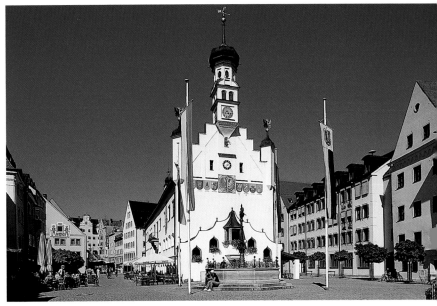

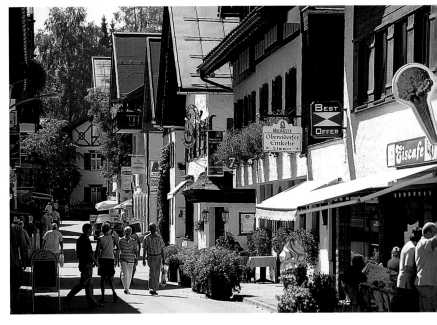

89

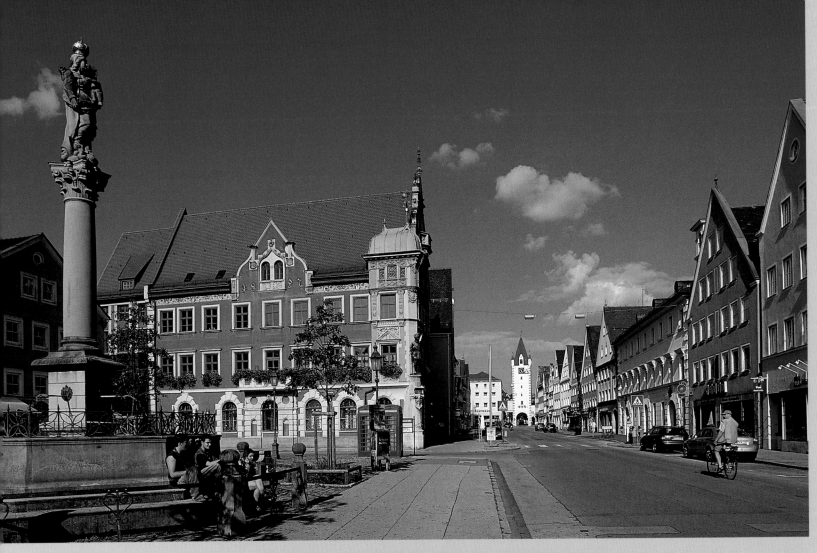

*Above:*
Mindelheim, in the Lower Allgäu district, was first documented in 1046 and was granted a town charter about 100 years later. Among the many sights in the historic centre are the Town Hall and Upper Gate.

*Right:*
The tax house, town hall and guild house in Memmingen. The town's history began as a Roman military camp and it was later a Free Imperial City on the intersection of the salt route from Ulm to Italy. In the 12th century, the Guelphs fortified the town, which contains many valuable historic buildings.

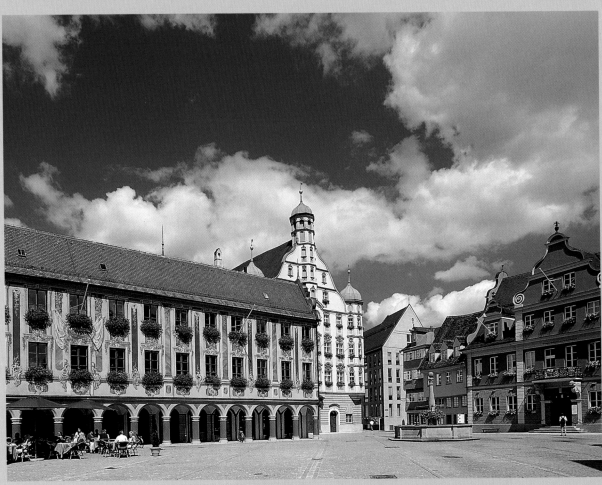

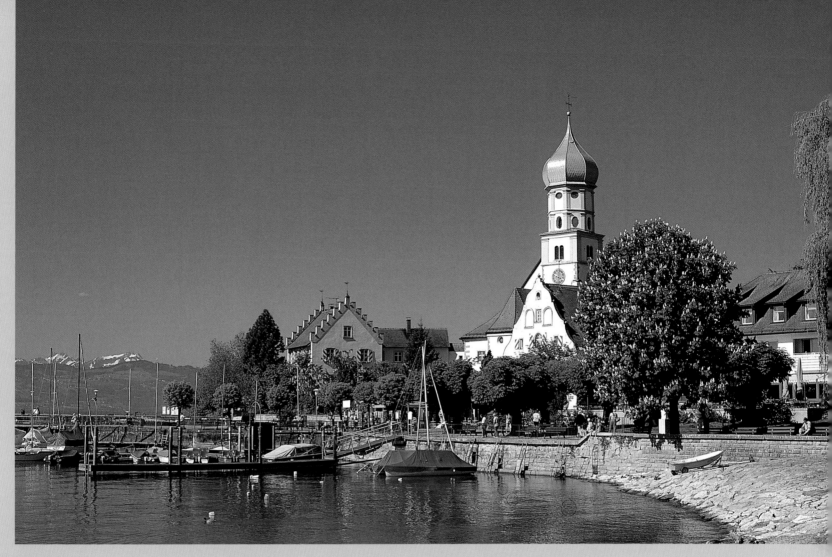

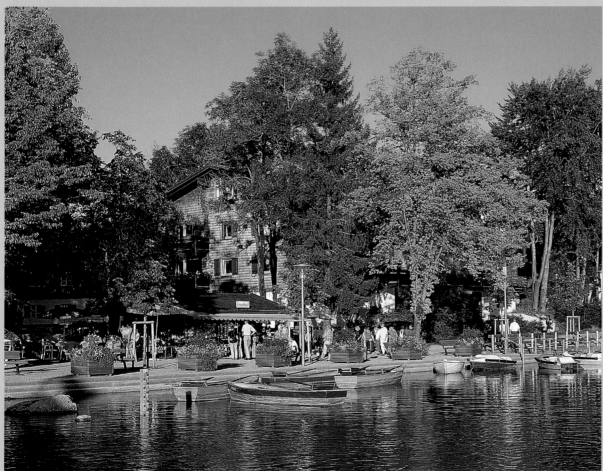

*Above:*
Wasserburg is called the "Pearl of Bavarian Lake Constance." The outstanding architectural heritage includes the 15th century Fugger Castle and the parish church dating from the mid-17th century.

*Left:*
Bühl on the Grosse Alpsee. Allgäu's largest natural body of water is a real paradise for water sports enthusiasts.

91

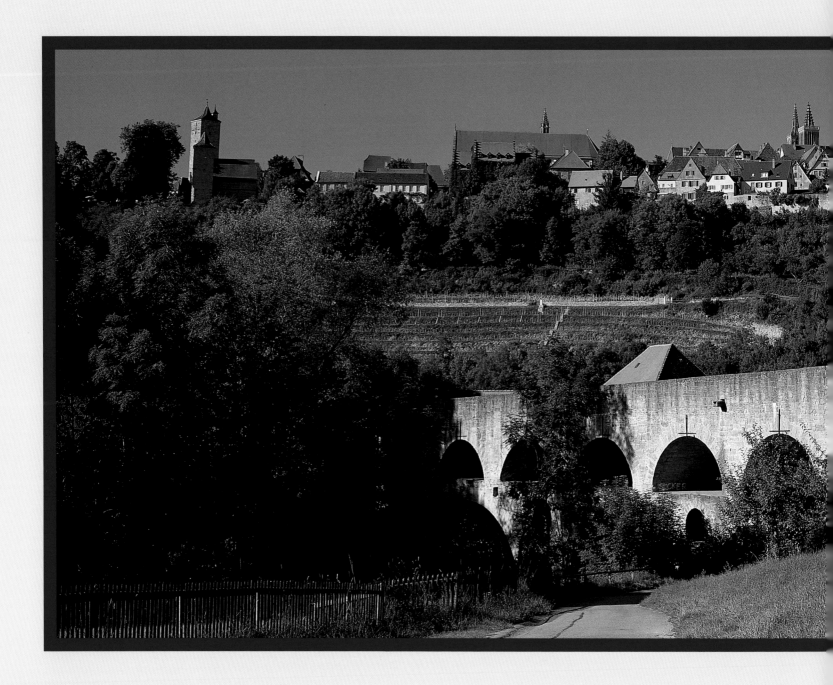

# FROM FRANCONIA TO BAVARIAN SWABIA

Franconia, wrote Goethe in his play "Götz von Berlichingen" is a "blessed land". This claim is underscored by the words of the nobleman Weislingen in the play: "My castle lies in the most blessed and delightful part, if I do say so myself." This varied landscape has more than its share of castles. The most in all of Germany – measured by area – are situated in the Fränkische Schweiz or "Franconian Switzerland." It also has the highest density of breweries than anywhere else.

Franconia became part of the free state of Bavaria about 200 years ago and is situated in the northernmost part. When such abstract terms as "upper" and "lower" meet with geography and

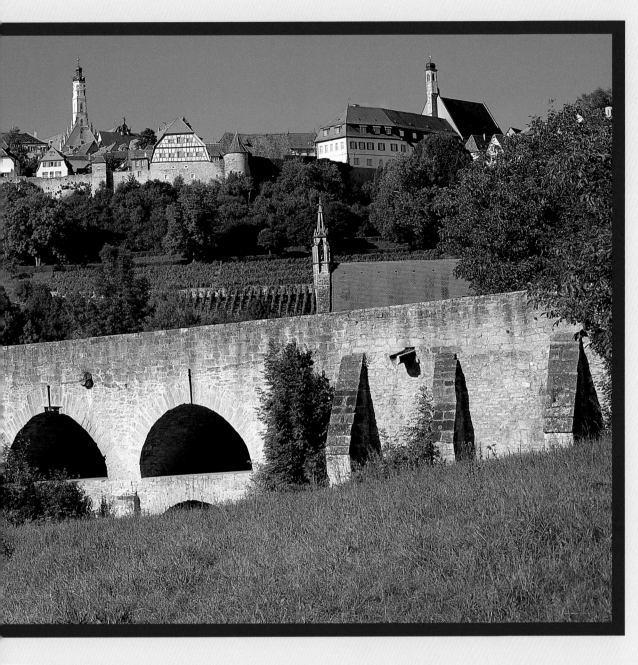

In the late Middle Ages, Rothenburg ob der Tauber was called a "German Jerusalem." The romantic town is a must even for tourists planning to spend only a day or two in Germany. The double bridge in the foreground spanning the Tauber was built in 1330.

then the middle has to be ascertained, there is much confusion even in orderly Bavaria. Those who seek Lower Franconia in the south will get just as lost as those who think that Upper Franconia must be in the north, while Middle Franconia is nowhere near the geographical centre of the region.

At any rate, the Upper Franconian government is seated in Bayreuth, alongside Richard Wagner or the lovers of Richard Wagner's music during the festivals. The palaces and gardens, by contrast, are governed by the quiet spirit of Margravine Wilhelmine, Frederick the Great's favourite sister.

# CATHEDRAL AND CASTLE OF THE KAISERS

Bamberg offers world cultural heritage. While the imperial Kaiser Cathedral there counts among the most important structures of the Middle Ages in Germany, Middle Franconian Nuremberg possesses the secular counterpart, the Kaiser Castle. Until the 16th century it was among the most popular and frequented residences of the German regents. Trade and the crafts flourished and the arts profited from the city's imperial wealth. Albrecht Dürer, Adam Kraft and Veit Stoss either were sons of the city or enriched it with their works.

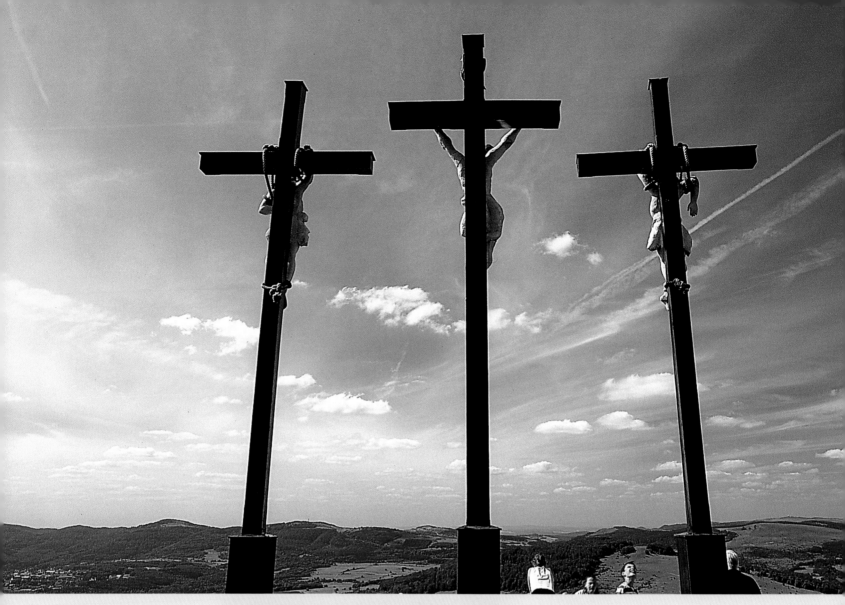

*Above:*
**On Kreuzberg. Legend tells that the later St Kilian and his two companions set up a cross here, thus giving Franconia's holy mountain its name. Malicious gossip has it that the related pilgrimage is so popular because the Franciscan monks brew such a drinkable beer.**

*Right:*
**Four major rivers begin in the northern Bavarian Fichtelgebirge. Besides the Saxon Saale, the two headstreams of the Main and the Fichtelnaab, the Eger also has its source here, marked in 1923.**

Like Nuremberg, Würzburg went under in the hail of bombs of the Second World War. Both cities were rebuilt long ago. However, while major parts of the historic fabric of the buildings in these cities had to be reconstructed, Rothenburg ob der Tauber can still proudly display the original thing, making it a showpiece known around the world.

The rivalry between yet two other historic storybook towns is great. Dinkelsbühl still clings to Franconia, while Nördlingen belongs to that part of the old Alemannic settlement region that became Bavarian about 200 years ago. Kaiser Ludwig the Bavarian erected its entirely preserved fortifying wall, which has encompassed the former city of the Holy Roman Empire in an almost perfect circle since 1326. The medieval master builders followed the natural contours of the Ries Crater, the aftermath of the strike by a huge prehistoric meteorite.

# SMALL TOWN TREASURES

Farther south, in the valley of the Upper Danube, some small town treasures invite us to visit. Donauwörth switched a number of times between Swabian and Bavarian rule, life as a city of the Holy Roman Empire and as a mere rural town. While Dillingen was the seat of government of the Augsburg diocese from the 15th century until 1803 and possessed its own university, the Wittelsbachs raised Lauingen, birthplace of Albertus Magnus one of the most important scholars of the Middle Ages, only to the status of second residence of their principality of Pfalz-Neuburg. Juxtaposed to these urban showpieces, Donauried and Donaumoos are two original natural landscapes that have survived human intervention.

From here, it is not far to Augsburg, a famed city even in Roman times and far into the Middle Ages. Augsburg's "Golden Age" took place in the 15th and 16th centuries, and today visitors still profit from its architectural and artistic legacy.

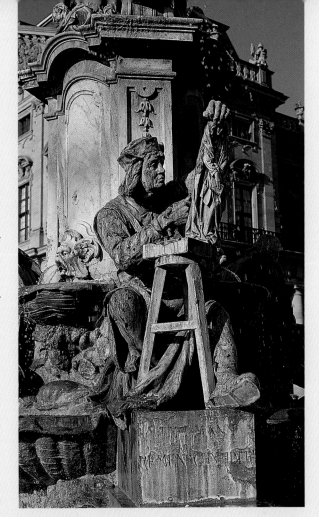

*Left:*
**The Franconia Fountain on Würzburg's Residenzplatz was erected in 1894 by Ferdinand von Miller as a tribute to the city upon the 70th birthday of Prince Regent Luitpold. The figures portray minnesinger Walther von der Vogelweide, painter Matthias Grünewald and sculptor Tilman Riemenschneider (photo).**

*Below:*
**The picture book town of Karlstadt not only has many old houses, towers and walls to offer, but also fine restaurants. The wine cellar "Beim Batzennärrle" at the end of the pedestrian zone is particularly original.**

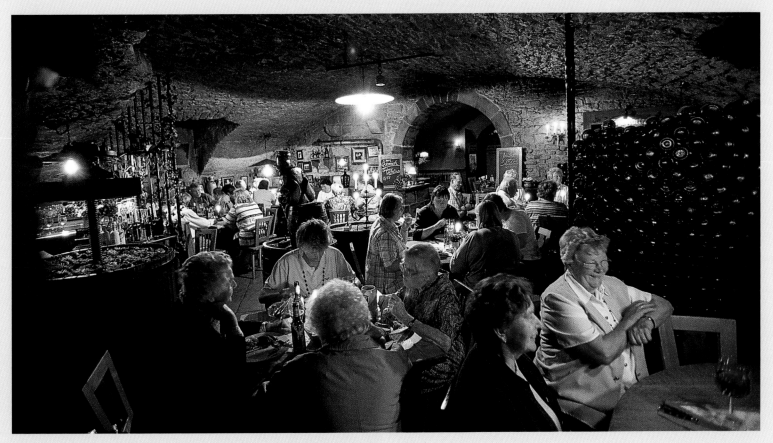

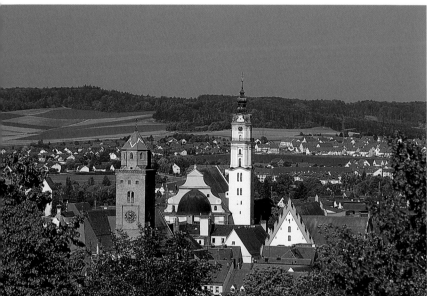

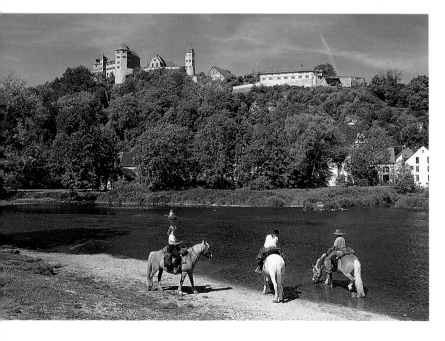

*Above left:*
The small town of Wemding to the east of Nördlingen owes its existence to Charlemagne. It passed from the abbey bishop of the Regensburg monastery St Emmeram to the counts of Oettingen and then – in 1467 – to Bavaria. The lovely market square is dominated by the two towers of the originally Romanesque parish church of St Emmeram.

*Centre left:*
For more than 1,000 years, Donauwörth was an important stopover for merchants as well as pilgrims travelling from the north of the continent to Rome. Thanks to this past significance, the town on the mouth of the Wörnitz to the Danube has a lovely historic centre with interesting churches and homes.

*Below left:*
Harburg Castle overlooking the town of the same name originated from a Staufen fortress. The buildings we see today were built in the 14th to 17th centuries.

*Below:*
View of Nördlingen from "Daniel" the tower of the parish church of St George, one of the largest German hall churches from the Late Gothic period. The town walls, which can still be walked along today, were erected in the early 14th century.

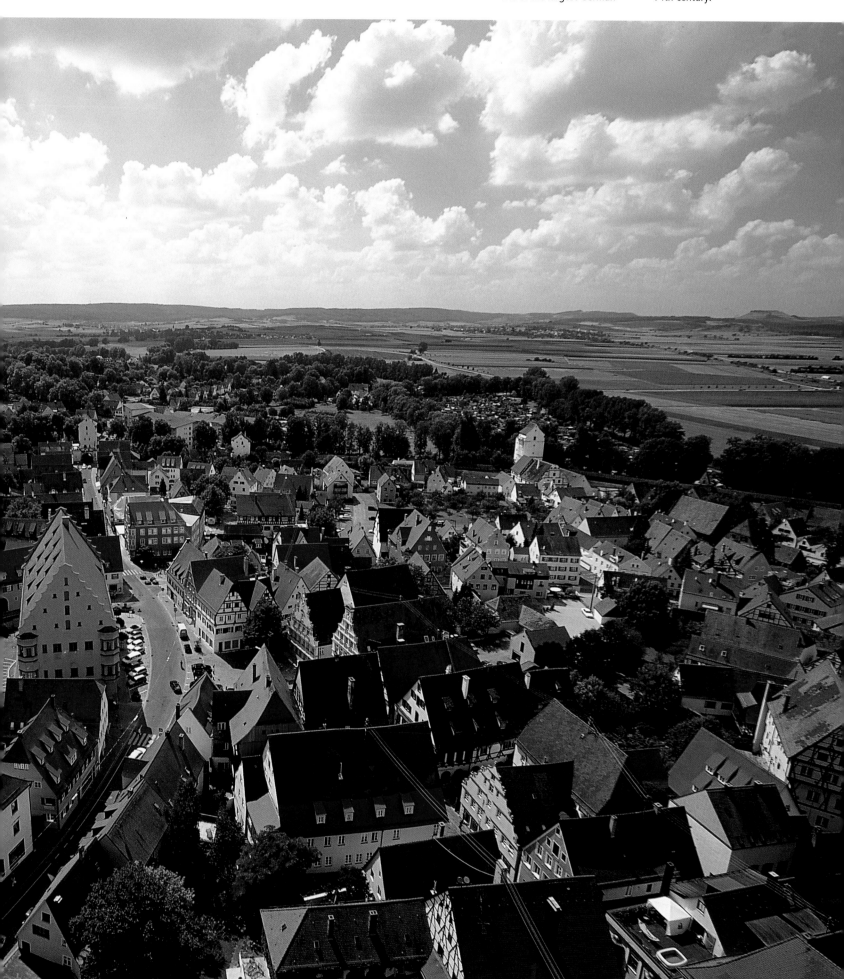

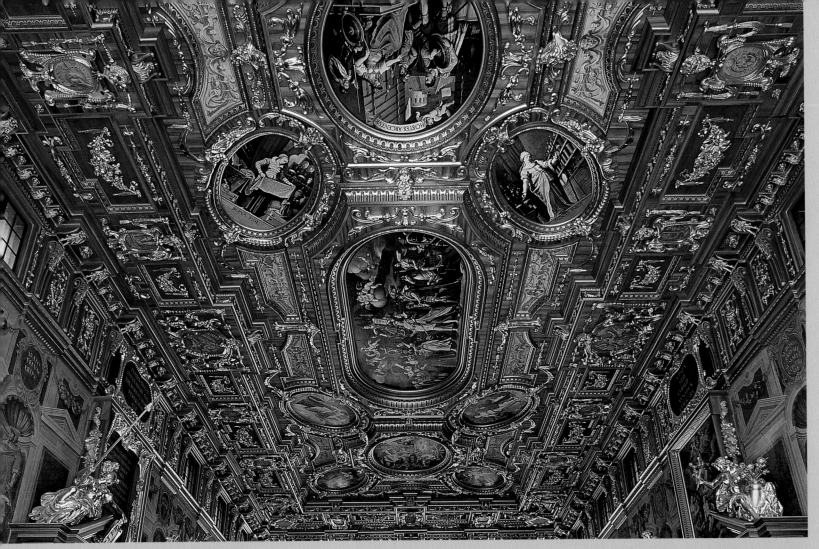

*Above:*
The Golden Hall of the Augsburg city hall, crowned by a magnificent ceiling, is one of the most splendid and original secular demonstrations of the Renaissance style in all of Germany.

*Right:*
There is a not only a lot to see in the Old Town of Augsburg, but plenty of good places to stop for refreshment. In spite of the many visitors, it's always possible to find a quiet place away from the crowds.

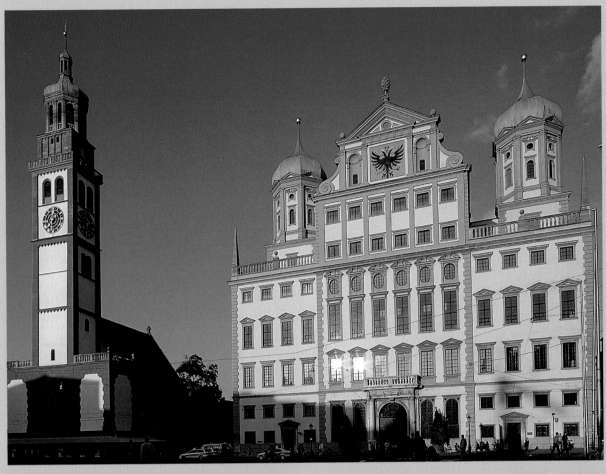

*Left:*
Among the many splendid buildings designed for Augsburg by Elias Holl are the Red Gate, the City Hall, erected between 1615 and 1620, and the neighbouring Perlach Tower.

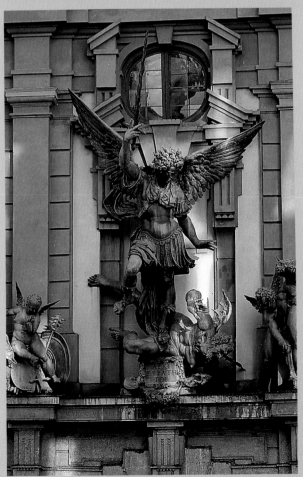

*Far left:*
Elias Holl lived from 1573 to 1646. From 1602 until his death, he was the municipal architect in Augsburg. The "Zeughaus", or armoury, was completed in 1607. The bronze group with Archangel Michael above the entry portal was sculpted by Hans Reichle.

*Left:*
The richly adorned gable of this building refers to a high-raking religious owner: the Augsburg Fronhof was once the residence of the bishops.

# THE FUGGERS

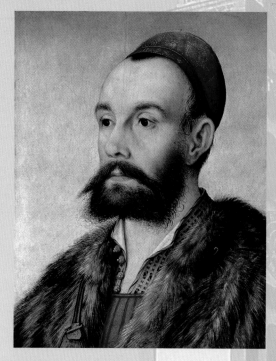

*Above:*
**In 1525 Hans Maler made this likeness of Anton Fugger, which is owned by the Karlsruhe Kunsthalle.**

*Below:*
**At the age of 58 years, Markus Fugger hired Jost Amman to cut his likeness in wood (Kunstsammlungen, Veste Coburg).**

The Fugger family originated in the town of Graben auf dem Lechfeld. They came to Augsburg in 1368, where they soon rose to become prosperous weavers. This, however, was not enough; while many others dreamt of gold at the end of the rainbow, they produced it. They recognized the signs of the times and took advantage of the resulting opportunities.

Two of the Fuggers, both named Jakob, earned outstanding merit. The first, son-in-law of the Augsburg mint master Bäsinger, invested in silver mines in Tyrol from 1448. He later turned to monetary transactions and combined this with commodity speculation. His son Jakob was even more successful, earning him the by-name "the Rich". Trained as a merchant in Venice, he brought spices overseas from eastern India as early as 1505 and sold them to anyone who could afford his princely prices. Jakob also transformed ore into money. In Upper Hungary, today Slovakia, he established the world's largest copper company with patronage in Krakow, Thorn, Venice, Nuremberg, Regensburg and Antwerp. Jakob was involved in every major

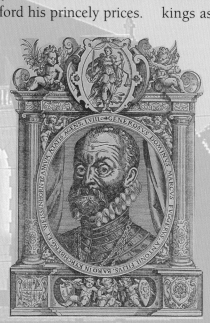

financial operation of his day. He not only controlled the flow of cash, but Kaisers and kings as well. He lent 70,000 gold guilders to Maximilian I in addition to furnishing him with 170,000 ducats in bills of exchange, with which the Kaiser was able to wage war against Venice. It's no wonder that he showed up in Augsburg so often. When Maximilian's successor was at issue, Jakob became a Kaiser maker; his money assisted Karl V to the throne. He was repaid by being raised to the peerage and his descendents given the title Count of the Empire.

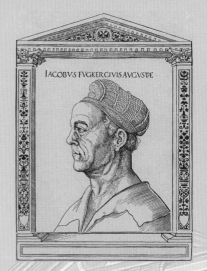

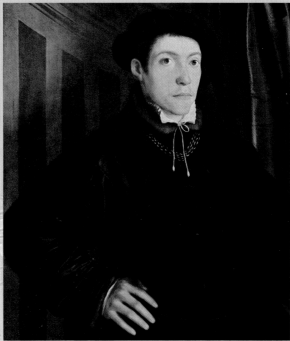

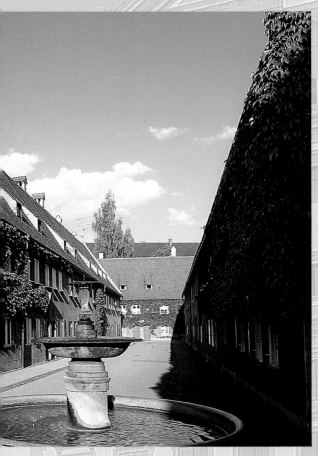

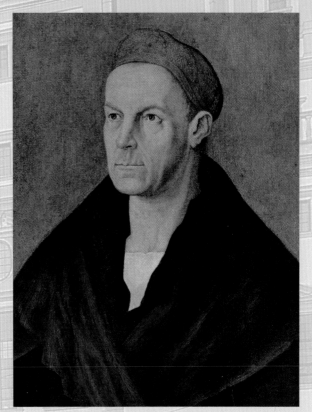

*Left:*
**A man who knows his own worth: Christoph Fugger, painted by the Augsburg artist Christoph Amberger in the year 1541.**

*Above left:*
**The Nuremberg artist Hans Sebald Beham also made a portrait of Jakob Fugger. His 1525 woodcut belongs to the collection of the Dresden Kupferstichkabinett.**

*Centre:*
**The flats in the two-storey row houses of the Fuggerei had three rooms and a kitchen together measuring approx. 60 square metres (646 square feet).**

*Left:*
**Albrecht Dürer painted this portrait of Jakob Fugger around 1519, which is shown in the Augsburger Staatsgalerie today.**

# FRIEND AND ADVOCATE OF THE HUMANISTS

In spite of all the money Jakob piled up, he did not lose sight of other important matters. The devout Catholic earned merit as a friend and advocate of the Humanists, who gave the "studia humana" (studies of the humanities) priority over religious studies. Needy people were the focus of an unprecedented social project launched by Jakob and his two brothers in 1516. They provided "hard-working, yet poor citizens" with 106 dwellings including furnishings. The recipients were expected to repay their beneficiaries with one symbolic guilder and a daily prayer for the donors. The "Fuggerei" still exists today, proving that they were far ahead of their times and the importance of putting money to work not merely for profits, but also for the people. The Fugger's Augsburg legacy includes not only this famous subsidized housing, but also the palaces on Maximilianstrasse as well as the burial chapel in St Anna's Church.

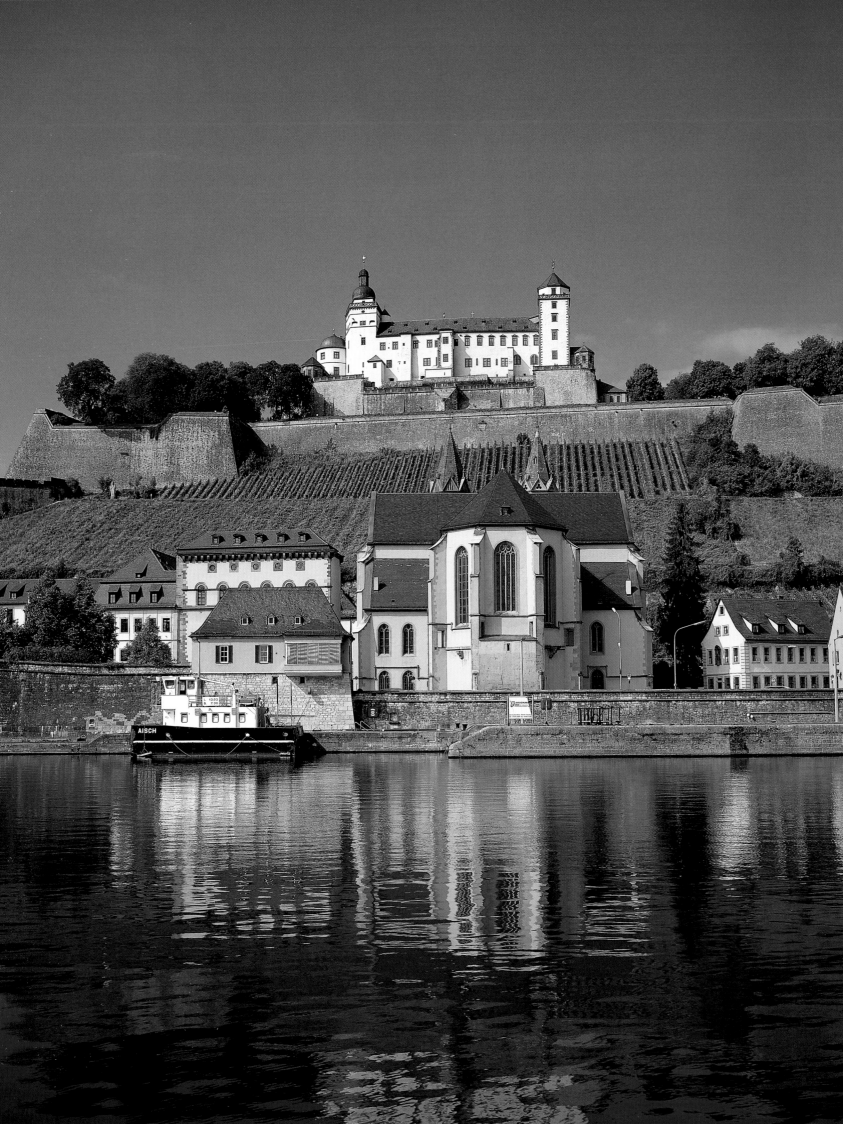

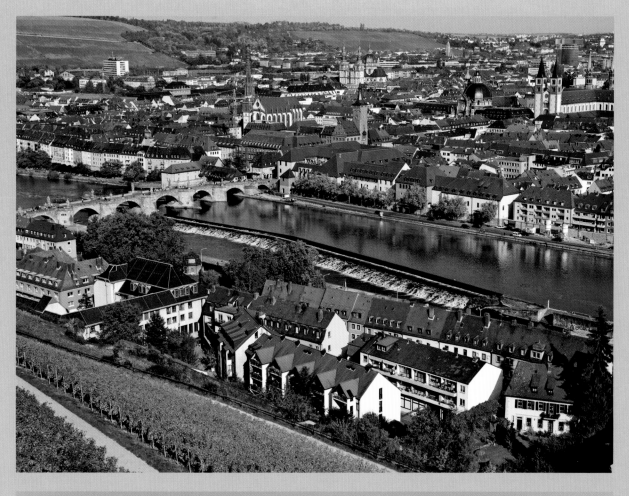

*Left-hand page:*
View across the Main to the
fortress of Marienberg, the
most famous landmark of
Würzburg. Once a central
diocese power, today it is the
home to many museums.
The showpieces of the Main-
fränkische Museum are the
works of Tilman Riemenschnei-
der. The Fürstenbau-Museum
gives us a look at the city's
history and at how the prince-
bishops lived.

There are unique views from
Festung Marienberg of the
River Main and the old town
of Würzburg, its red carpet of
roofs punctuated by a bizarre
collection of towers and
steeples. The Alte Mainbrücke,
adorned with 12 saintly statues
fashioned in the 18th century,
has linked both halves of the
city since the Middle Ages.

Würzburg is a city of spires. From
left to right you can see the belfry
and dome of the Neumünster, the
tower of the town hall or Grafe-
neckart, with the pointed spires
of St. Johannis in the background,
and the four distinctive towers of
the cathedral, the city's chief
place of worship. The cathedral
facade was renewed in 2007,
giving Kiliansplatz a sparkling
new visage.

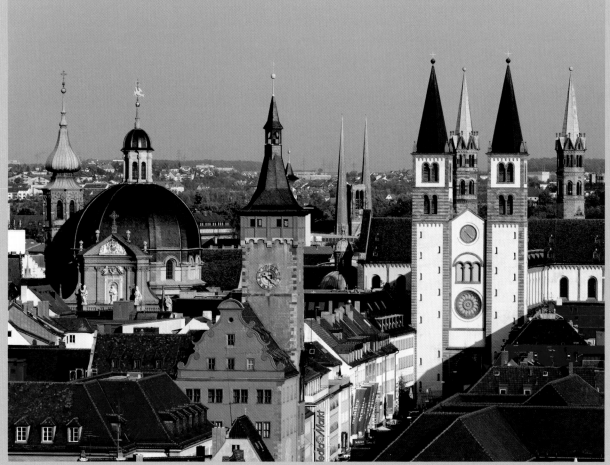

*Below:*
The fortress of Marienberg was built over a castle with a chapel to Mary erected around 700 by Duke Hetan II. The Würzburg bishops took over the mountain in the 13th century and the powerful castle was not conquered until the Thirty Years' War by the Swedes.

*Below:*
The Würzburg market square offers two outstanding architectural monuments. The High Gothic Chapel of St Mary, for which Tilman Riemenschneider sculpted the marvellous figures of Adam and Eve for the southern portal, was originally the parish church of the citizenry. The ornate stucco façade of the neighbouring Falkenhaus was made in 1751.

*Right:*
The former residence of the Würzburg prince-bishops was declared a UNESCO world heritage site as early as 1981. The undisputed showpiece of the huge, three-winged structure chiefly designed by Balthasar Neumann is the arched staircase with the ceiling painting by Tiepolo.

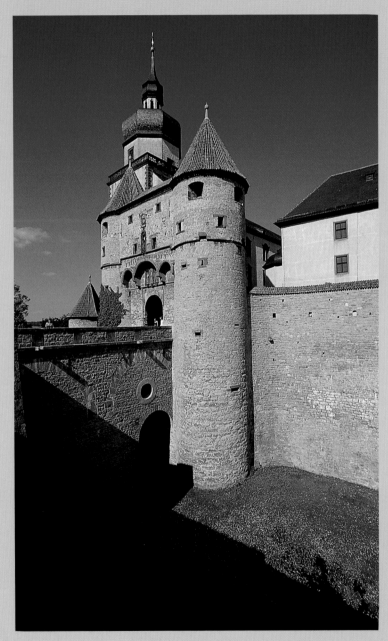

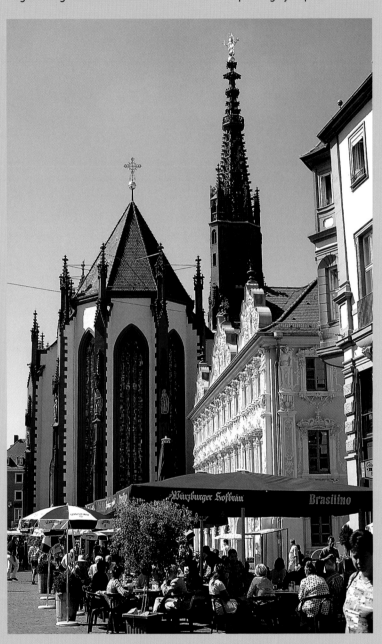

*Right:*
Between 1747 and 1750, Balthasar Neumann erected a church dedicated to the Virgin Mary on the Nikolausberg across from the Würzburg fortress over an older pilgrimage chapel. The place of worship faces the Main valley with its graceful double-towered façade.

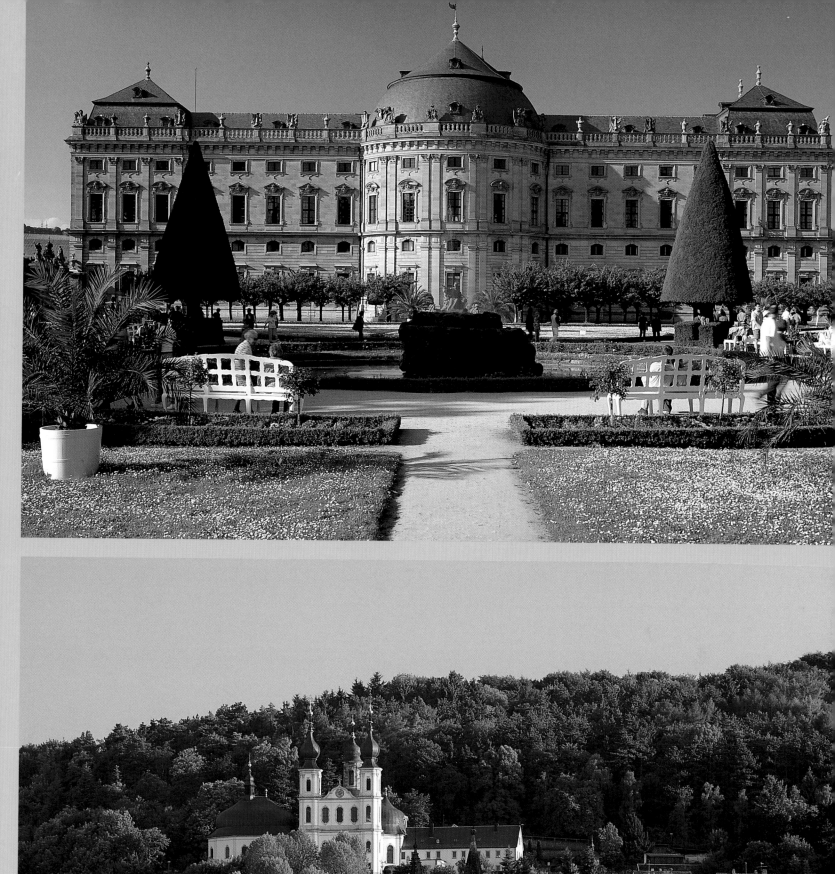
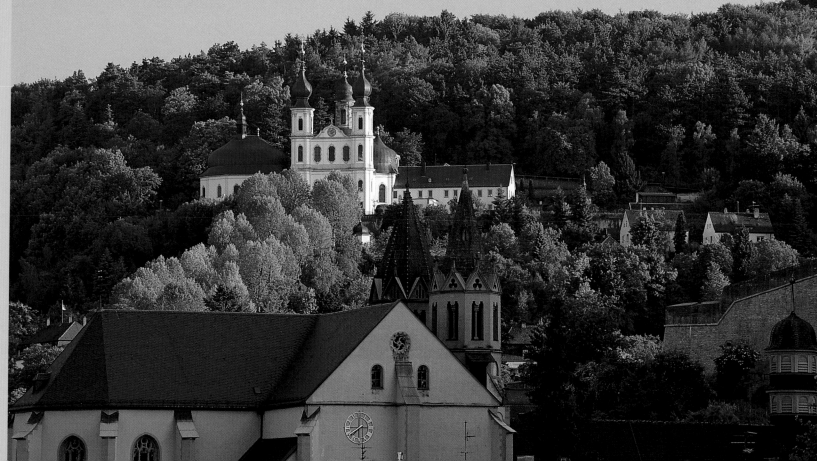

*Below:*
The interesting small town of Karlstadt originated under the Würzburg bishop Konrad von Querfurt, who founded a settlement opposite the Karlburg, today a ruin, about 1200.

The town's chessboard-like street layout within a rounded rectangle imitated the fortresses of the crusaders in the Holy Land and guaranteed optimal defences.

*Above right:*
Lohr, which calls itself the "Gateway to the Spessart", was first documented in 1296 and until the mid-16th century was residence of the counts of Rieneck, whose well-crafted tombs can be admired in St Michael's Catholic Church.

*Centre right:*
The Rödelsee Gate in Iphofen is one of the most-photographed subjects in Franconia. The picturesque defensive structure, with its outside enclosure, was built in the 15th century and is one of three gates in the ring of the city walls.

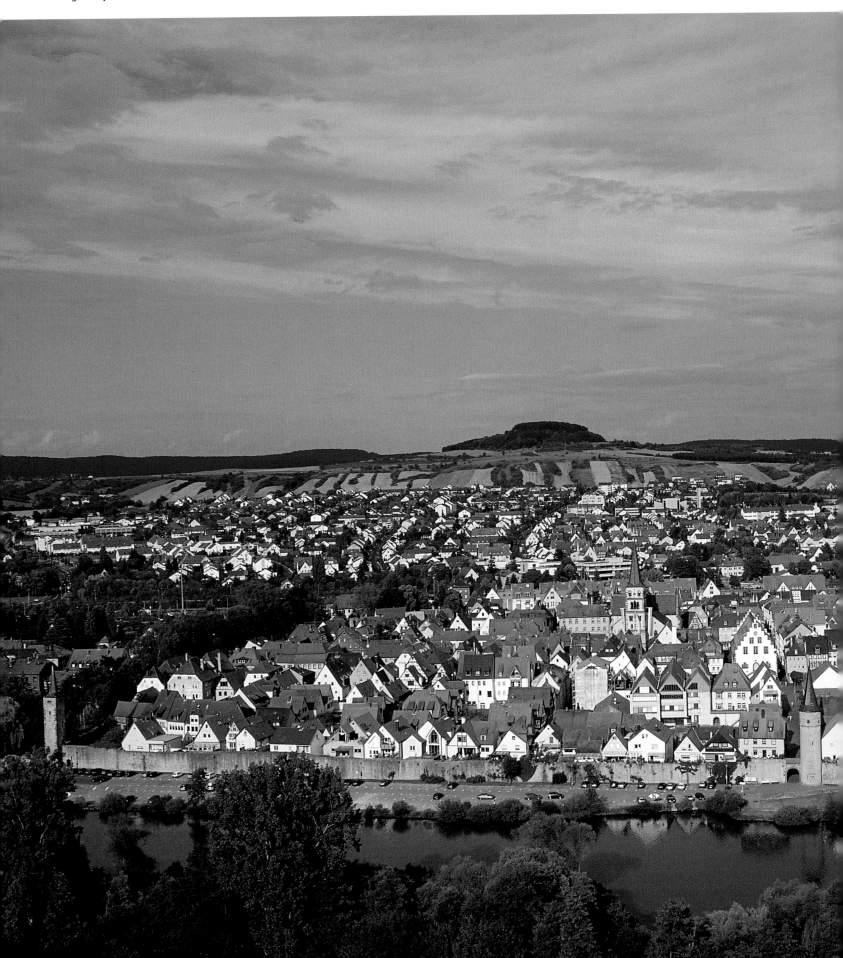

*Below right:*
Marktbreit is another urban treasure on the Main River. The small town did not belong to the Würzburg diocese, but to the Seinsheim house and later the princes of Schwarzenberg. Seinsheim Castle in the centre of town was built in the Renaissance style.

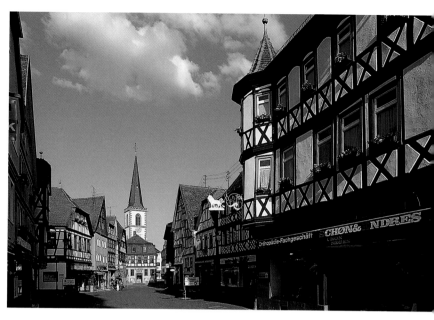

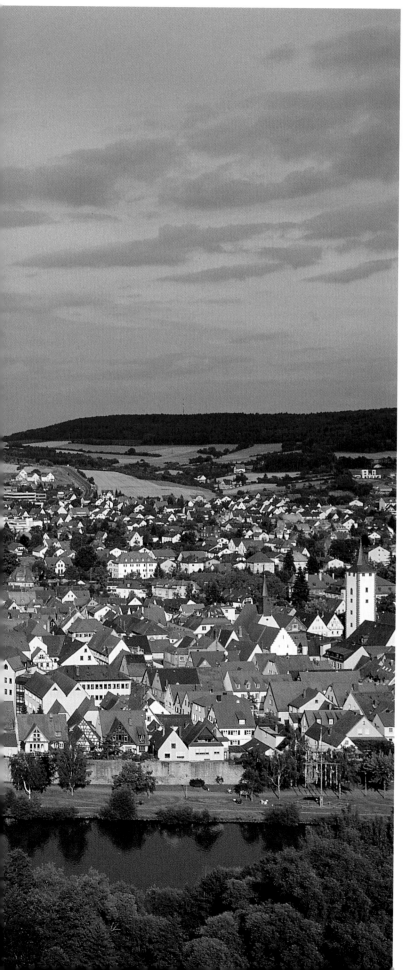

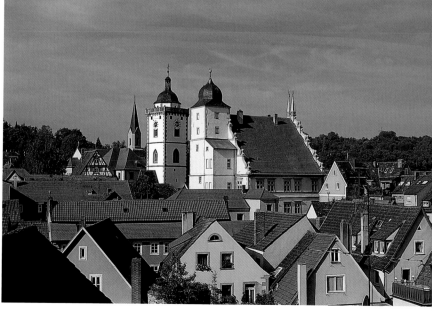

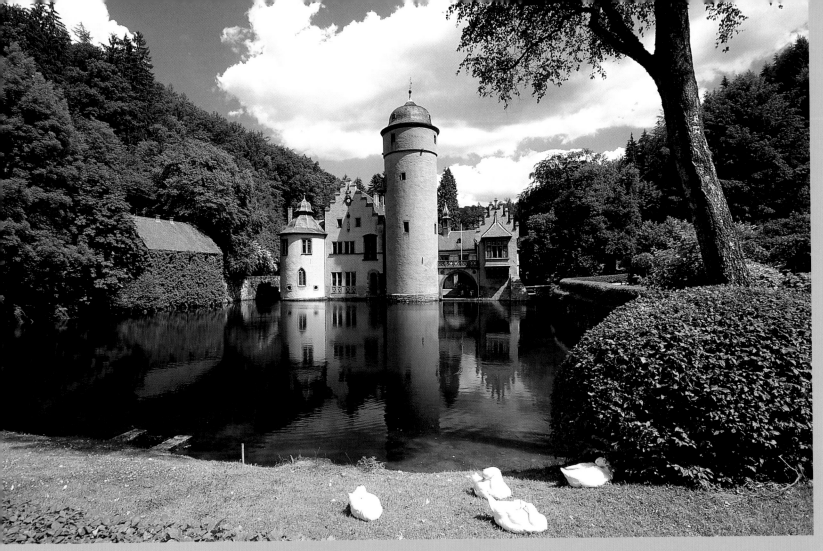

*Above:*
Franconia's fairy tale castle is called Mespelbrunn and lies hidden in the Spessart forest. Julius Echter, prince-bishop of Würzburg who founded a famous hospital and launched the counter-reformation with fire and sword, was born here in 1573.

*Right:*
Although the notorious Spessart tavern from the fairy tale stands no more, this low mountain region with one of Germany's largest forested areas is still full of secrets. The originally dominant oak trees have been replaced largely by red beeches.

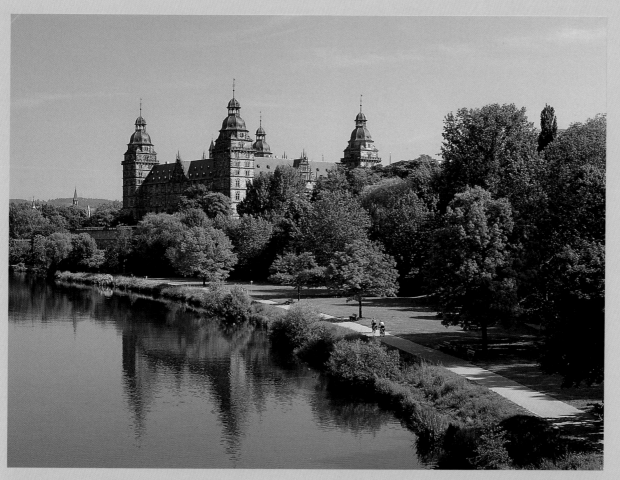

*Left:*
Johannisburg Palace in Aschaffenburg, a huge four-winged red sandstone structure, was built between 1607 and 1614 according to plans by the Alsatian architect Georg Ridinger. The former summer residence of the Mainz electors and archbishops is one of the nation's most outstanding Renaissance palaces. It was restored after suffering heavy damages in the Second World War.

*Below:*
Bad Brückenau owes its heyday to Bavarian King Ludwig I, who honoured the town with his presence 26 times in 44 years, thus making it the unofficial summer capital of the country. In those days, the Fürstenhof, bordering the park toward the hill, was the living and government quarters.

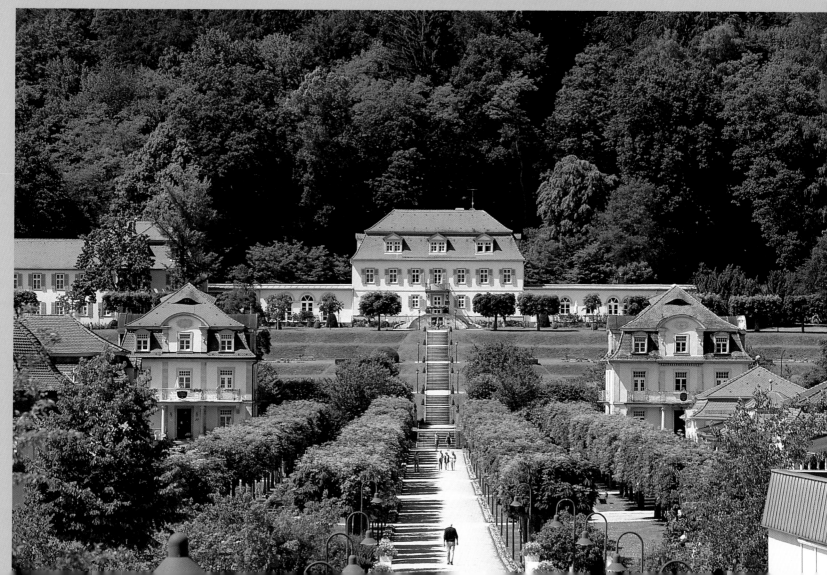

*Below:*
The poem says you can drink yourself to death with Klingenberg red wine. Nevertheless, the steep vineyards bowing towards the Main produce a quite delectable red wine, rarely cultivated in Franconia. The town's name comes from the old Clingenburg castle, only a ruin today.

*Above right:*
The nucleus of Amorbach is a monastery built in the 8th century. Its Baroque church built by Maximilian von Welsch still charms visitors today.

*Centre right:*
The loop of the Main around Volkach offers delights for the eyes as well as the palate. Of course, Bacchus once had his largest Bavarian branch office here. Hotel "Behringer" with its cosy courtyard is one of the highly recommendable restaurants in the area.

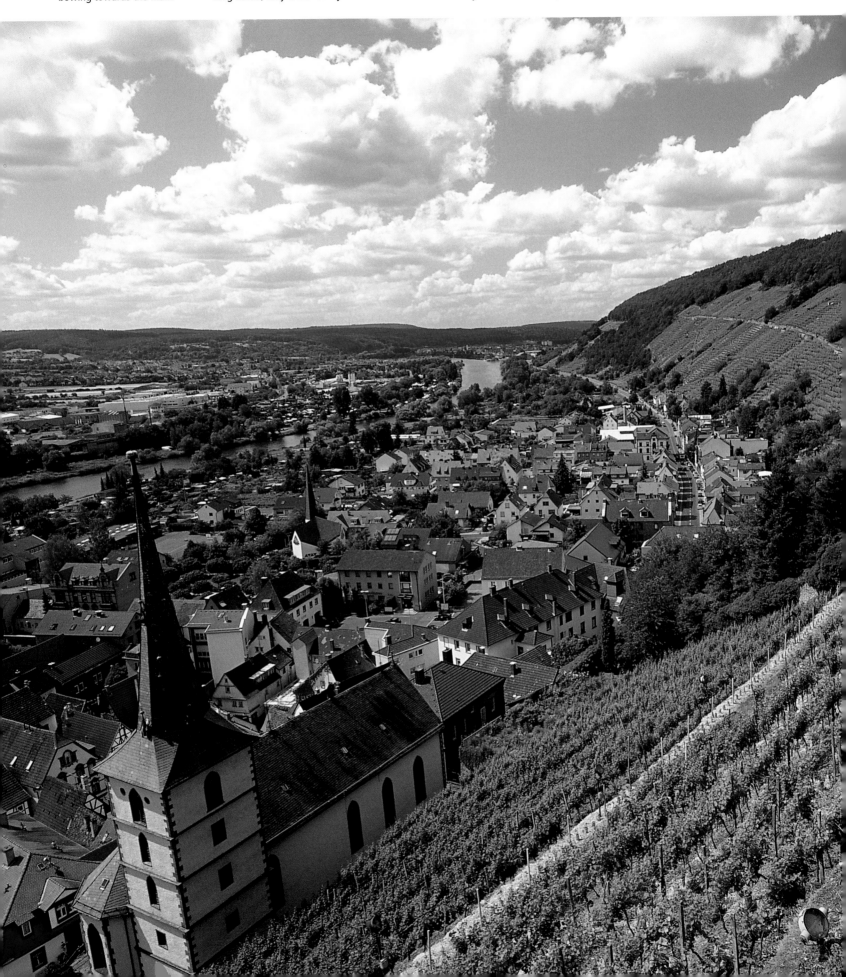

*Below right:*
The market square of Milten-
berg is one of the loveliest and
most well known in Germany.

Stunning half-timbered houses
cluster around a red sandstone
fountain crowned by the
allegorical figure of Justice.

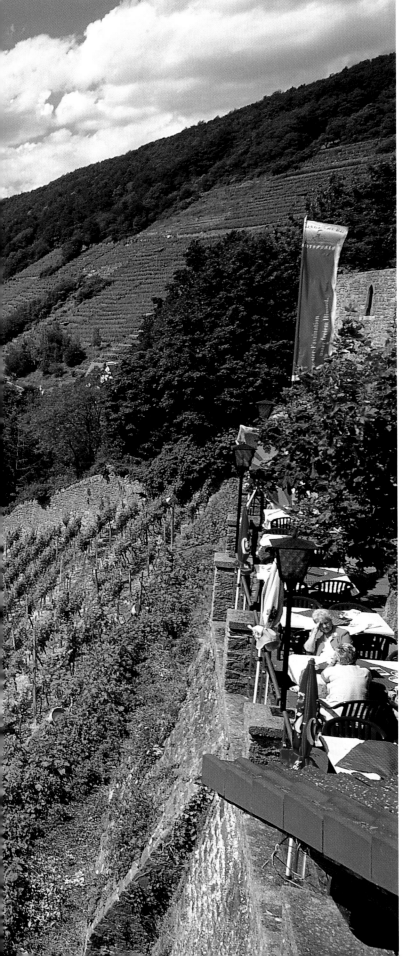

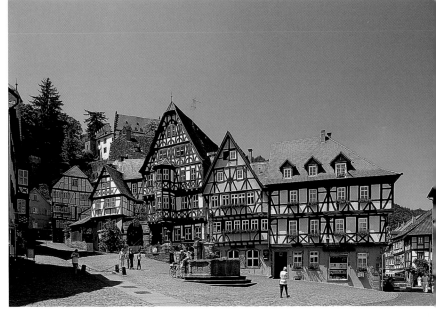

# MAIN RHYMES WITH WINE OR
# FRANCONIAN WINE

The first to praise the wines of Franconia was the scholar Hildegard von Bingen, who more than 800 years ago confirmed it had better healing affects than any other wine. About 1650 the virtues of Franconian wine were even proverbial. Of the three most famous German wine towns, two were situated in Franconia:

*At Würzburg on the Stein,*
*At Klingenberg on the Main,*
*At Bacharach on the Rhine,*
*There grows the finest wine.*

Approximately 150 years later, Goethe himself admitted to being a famous lover of the local grape juice. He especially enjoyed the Würzburg "Steinwein" and Escherndorfer, which he had shipped home to Weimar.

*Above:*
**The wine festival in Sulzfeld. Although Main Franconia has more than its share of wine festivals, none complains of a lack of visitors.**

*Right:*
**A guided tour through the wine cellar of the Würzburg Juliusspital, one of the finest in Franconia, is a special treat.**

However, it was not merely the quality, but the quantity of the wine produced in Franconia that long set the standard. Years ago, the area used for vineyard cultivation was roughly seven times as large as that today. It encompassed about 40,000 hectares (100,000 acres) and reached to the Upper Main. In those days, Bacchus's German headquarters were not in Rhinehesse or the Palatinate, but in Franconia. Not until much later did his territory there shrink to about 6,000 hectares (15,000 acres). Franconian wine remains a noble drop to this day. Keuper, shell limestone, red sandstone and primary rock soils nurture some red varieties (Burgunder, Portugieser, Schwarzriesling, Domina and Dornfelder) next to the white grapes:

Müller-Thurgau, Grauer Burgunder, Riesling, Kerner, Traminer, Perle, Bacchus, Scheurebe, Rislaner, Ortega and, of course, Sylvaner. This last variety takes up approximately one fifth of the vineyard land and long was considered a Franconian strain.

# THE SCENIC MAIN RIVER LOOP

The Main River is bordered by towns with evocative names forming a sheer endless grape-like garland. Its spirited escapades near Volkach – the river loop – are applauded by 40 percent of all Franconian grapes. At the many wine festivals celebrated from early summer to late autumn, glasses and hymns of praise ring to the delicious beverage, which is best accompanied by a hearty

You can tell it's Franconian wine by the unmistakable shape of the bottles. Called "bocksbeutel", the origin of the bottle is disputed.

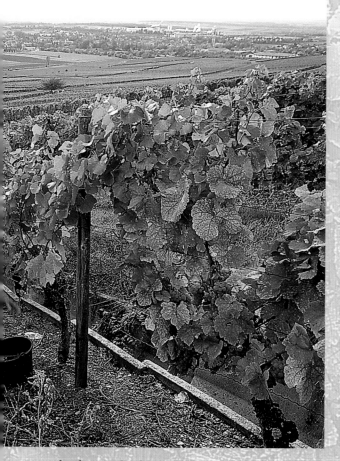

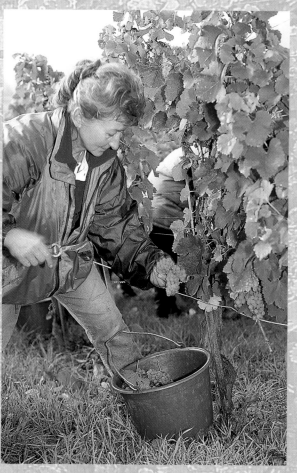

*Left:*
The grape harvest is an especially important date in the winegrower's year. This is the time when the quantity and quality of the new wine is determined.

*Centre:*
Iphofen, the home of a number of famous winegrowers, supplied the coronation wine for Queen Elizabeth.

*Below:*
A lunch break amidst the grapevines tastes all the better after a hard morning's work at the wine harvest.

meal. Those who like it quieter come in spring to the marriage of asparagus and wine. All months with an "R" are Main "Waller" time and the noble catfish is best flattered by a bottle of dry Sylvaner.

Wine has not only conquered the Main, but also the sunny slopes of the Steigerwald. In addition to delicious foods, there are a number of exquisite Old-Franconian style towns and villages. Guarding over it all, with its broad stony roots between the grapevines, is the mountain of Schwanberg. Legend says that mysterious maidens dwelt here who adorned themselves in cloaks of feathers and flew close to the heavens.

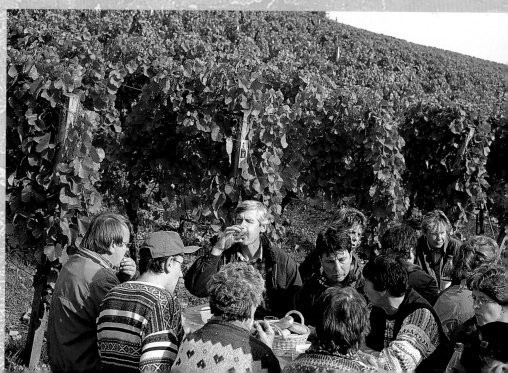

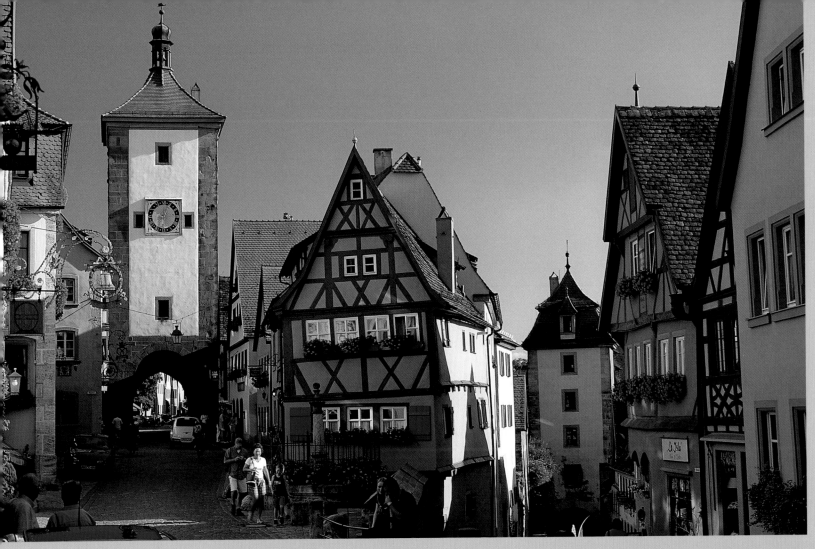

*Above:*
Of the many picturesque spots in Rothenburg ob der Tauber, the "Plönlein" – with the two high gate towers in the background – is one of the prettiest.

*Right:*
The late medieval gem-like town of Dinkelsbühl, with most of the Old Town buildings going back over 400 years, was once a Carolingian royal court. The annual historical play, the "Kinderzeche", recalls Swedish occupation during the Thirty Years' War.

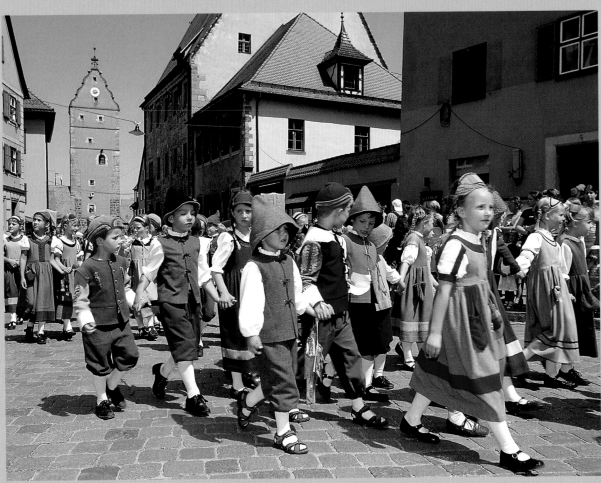

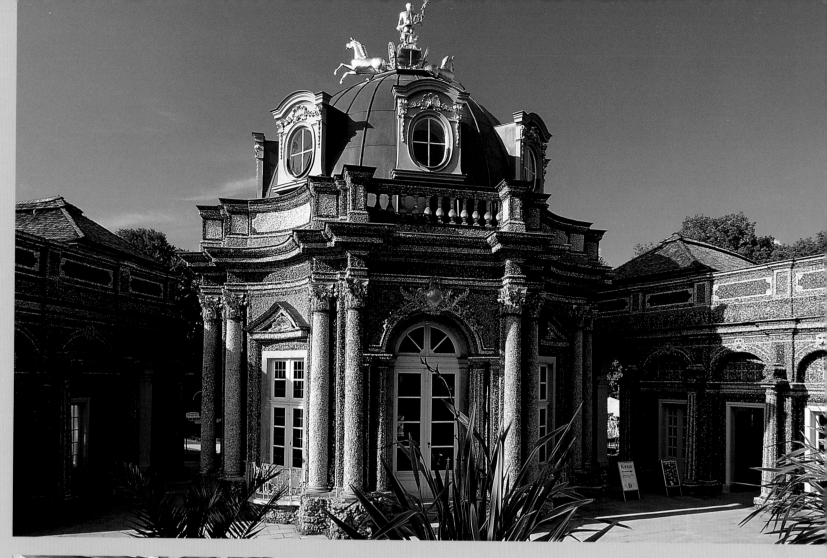

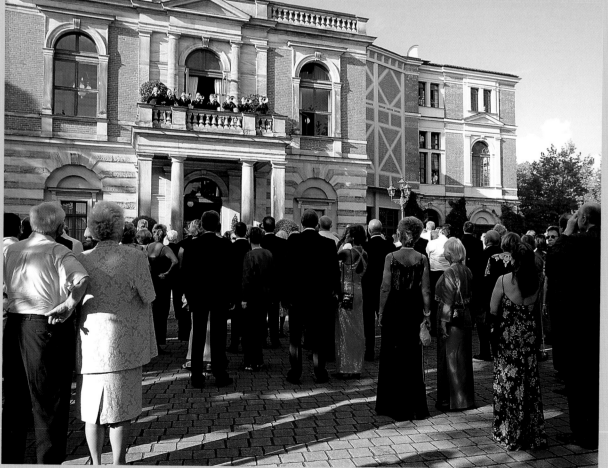

*Above:*
The park landscape of the Eremitage in the loop of the Red Main was made a hub of courtly life in Bayreuth by Margravine Wilhelmine.

*Left:*
Bayreuth has been host to Wagner-enthusiasts streaming to the famed festivals from around the world since 1876. Although the temple of the muses on the "Green Hill" seats nearly 2,000, they must be reserved years in advance. A guided tour of the building is recommended even for those who are not great Wagner fans.

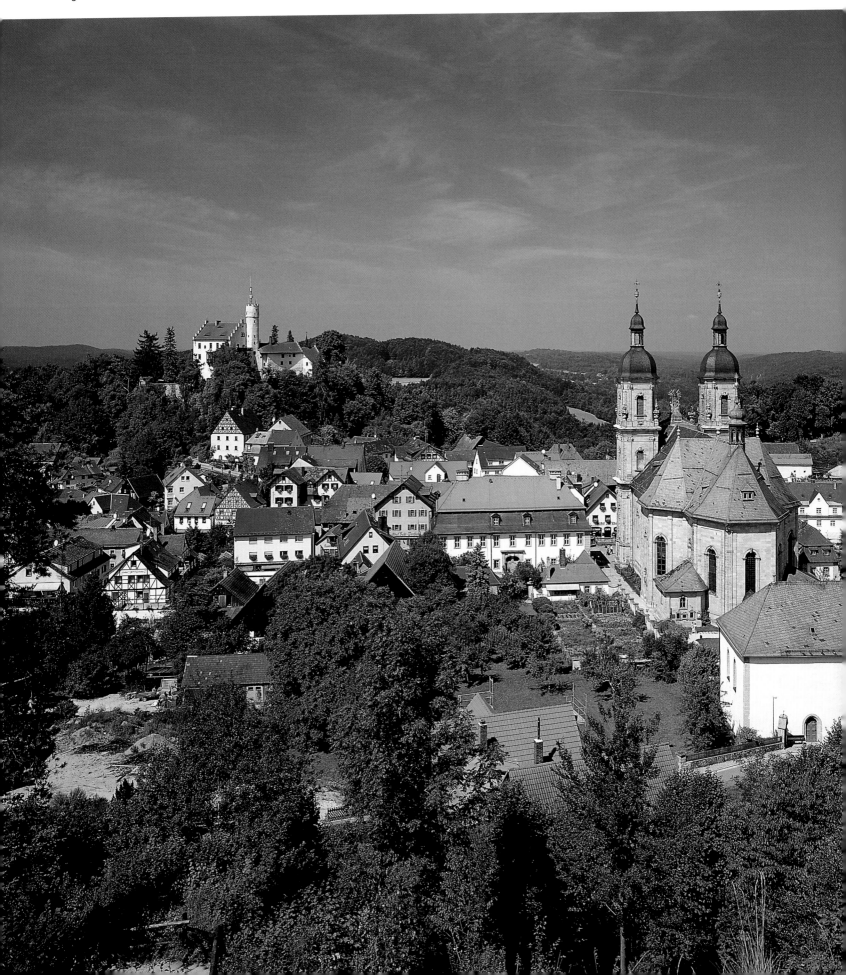

*Below right:*
Little Tüchersfeld in the Püttlach valley is overlooked by huge towers of rock. Hard to believe that castles once stood on them. You can enjoy the magnificent panorama from the road, but it's worth it to climb up as well.

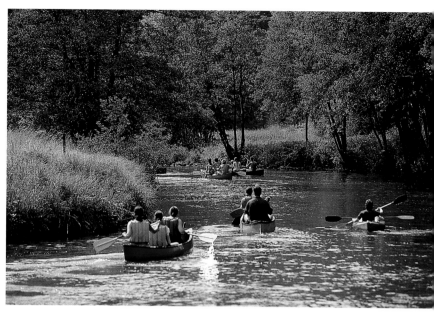

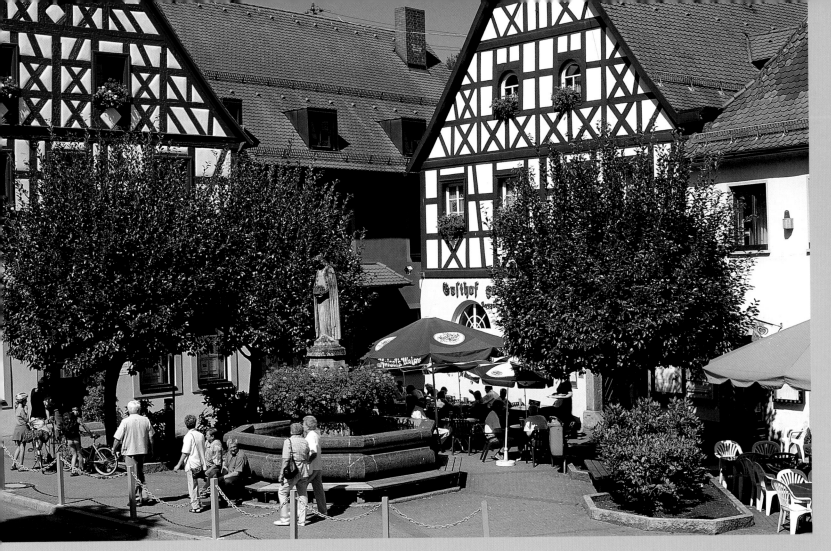

*Above:*
Surrounded by picturesque cliffs, the town of Pottenstein in Franconian Switzerland merges the streams of tourists. Although the town was the victim of two large fires in the 16th and 18th centuries, many pretty half-timbered houses survived.

*Right:*
Kulmbach, for many Germany's unofficial beer capital, has a real treat for art lovers as well with the Plassenburg. The highlights of the spacious castle from the 12th century are the arcade-encircled "Schöne Hof" and the world's largest collection of tin soldiers.

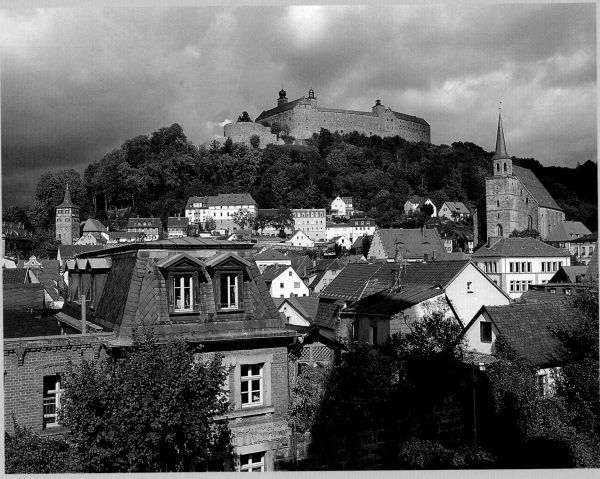

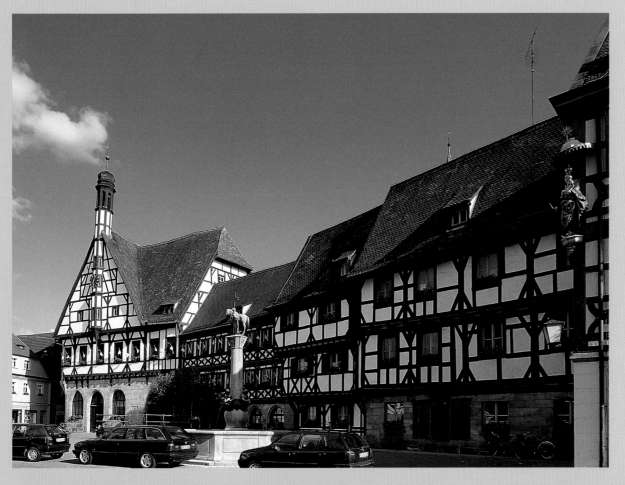

*Left:*
Together with the adjacent houses, the town hall of Forchheim, with the oldest section dating to the late 15th century, provides a splendid half-timbered backdrop to the market square. Every December the front is transformed into what the Guinness Book of World Records calls the "world's largest Advent calendar".

*Below:*
Small, but stately: Sesslach in the Coburger Land is entirely surrounded by a towered city wall. In the 1980s, the townspeople were awarded first prize in a national contest for the exemplary restoration of their picturesque municipality.

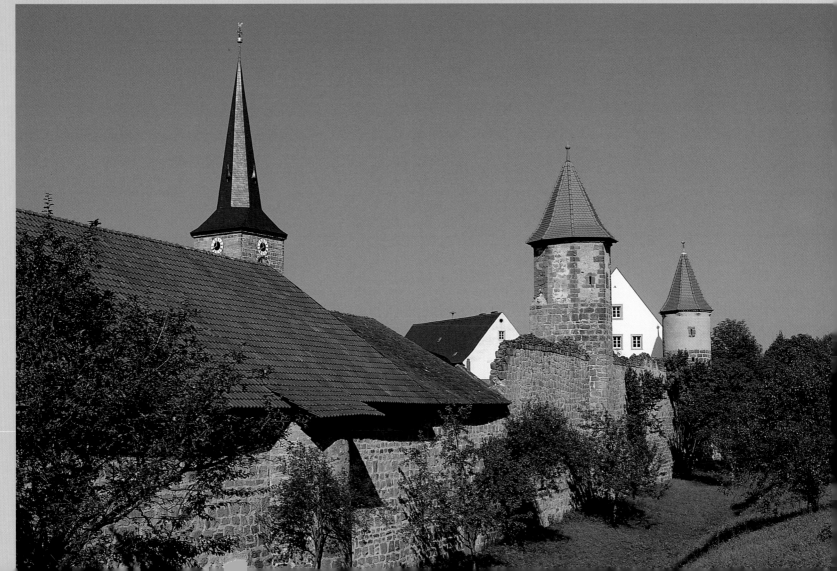

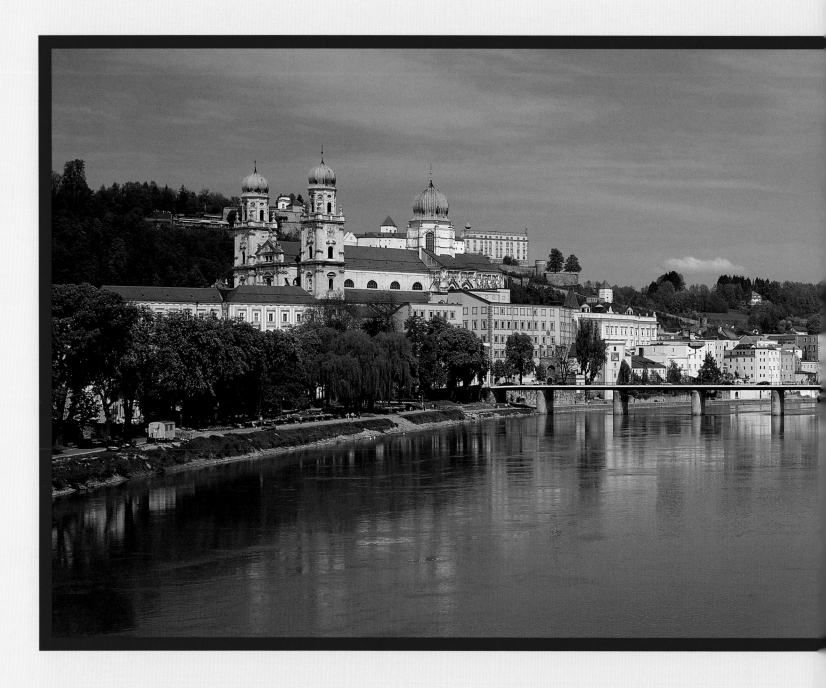

# FROM LOWER BAVARIA TO THE UPPER PALATINATE

Bavaria's east was not developed for tourism until after the Second World War. One of the old wives' tales heard at evening gatherings by the fireplace is that in the 1950s, many a boarding house in the Bavarian Forest had only one key that had to be shared by both kitchen staff and guests. It is also hard to believe that for centuries the region had less than a handful of roadways.

At any rate, this region has nothing to hide today and the number of those who come here to breathe "Germany's cleanest air" and seek active recreation both in summer and winter increases year for year.

Passau: the view from the Inn landing stage to St Stephan's Cathedral. It took twenty years for Carlo Lurago to erect Bavaria's largest High Baroque church on the foundations of its predecessors.

Lower Bavaria is not all forest however; the region is also characterized by the Danube with fertile water meadows lining its banks. The heart of "old Bavaria" beats in Straubing in time to the chiming bells of the splendid Baroque monasteries and churches of Metten, Niederaltaich and Osterhofen-Altenmarkt that surround it. The cities of Landshut and Passau are also among the loveliest in the state. Things become almost Mediterranean in Passau, where architects, artists and stucco sculptors from Upper Italy and Tyrol introduced the shapes, colours and architecture of their homelands to the city where waters of three rivers (Danube, Inn and Ilz) lap six shorelines.

## LATE DISCOVERIES

Water – hot water – brought fame to three Lower Bavarian towns. While Füssing already had a hot spring and more than modest swimming baths to call its own after the war, the Rottal hot springs were not discovered until the 1970s, transforming the two rural towns of Birnbach and Griesbach practically overnight into celebrated bathing and spa centres.

The Oberpfälzer Forest is virtually nothing more than the Bavarian Forest's northern little brother. At its creation, however, nature must have run out of steam for a moment, for the chain of hills

131

is broken at the Cham Basin and Furth Valley. It is a gap large enough to allow not only traders and wagons of goods to pass through but also the armies of powerful warlords who pillaged and plundered everything in their path. For many years, the Upper Palatinate was thus known as the "poorhouse of Bavaria."

Monks were the first to settle here. The library of Waldsassen Monastery houses its most magnificent showpiece, carvings by Karl Stilp interpreting representatives of all the bookmaking professions with much irony and sarcasm. Books also play a special role at St Emmeram's Monastery in Regensburg, in whose scriptoria the most beautiful and valuable volumes of Carolingian manuscript were produced. The best known is the "Codex Aureus", which the city lost to Munich

in the wake of secularisation. Regensburg still has much to offer, however, with a rich history going back 2,000 years.

## PERPETUAL IMPERIAL DIET

Regensburg began its history as the Roman military camp "Castra Regina". Later, Regensburg would become the capital of the Bavarian tribal dukes and then, after power was taken by the Carolingians, the residence of the East Franconian kings. The city of the Holy Roman Empire possessed not merely extensive trade connections throughout Europe, but was also the scene of important imperial assemblies and, from 1663, as the venue of the "Perpetual Imperial Diet," was the capital of the Kingdom of Germany in the Holy Roman Empire. Nowhere else hereabouts

than 300-metre (1,000-foot) long stone bridge that has spanned the Danube since the 12th century. Nevertheless, the most distinguishing landmarks of Regensburg are those medieval high rise towers, which recall San Gimignano in Tuscany.

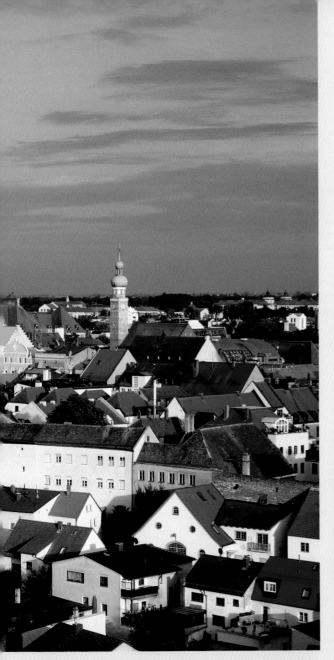

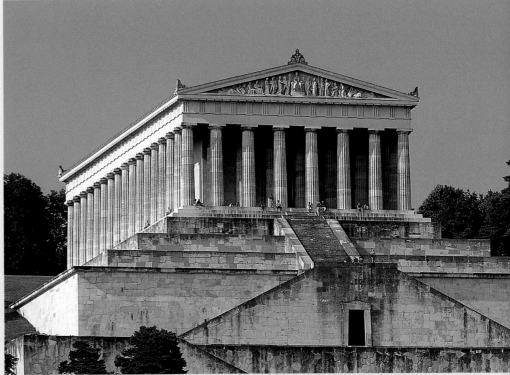

*Below:*
**"Walhalla" near Donaustauf thrones high above the Danube. The monumental structure in the form of a Greek temple was initiated by King Ludwig I and designed by his court architect Leo von Klenze. It houses the busts of "famed and outstanding Germans" – of which only four women are included.**

one can track "such unbroken development of a political unit from Roman times to the present" as in the historic Old Town of Regensburg (H. Schukraft).

This Old Town has a number of spectacular landmarks, such as St Peter's Cathedral and a more

*Far left:*
**Every August the "Drachenstich" in Furth im Wald draws thousands of visitors. A parade is part of the spectacle, but most people come to see Knight Udo slay the fire and smoke breathing dragon.**

*Left:*
**Regensburg's Spitalgarten is among the many refreshing stops in the old Danube city, where one can eat and drink well in romantic surroundings.**

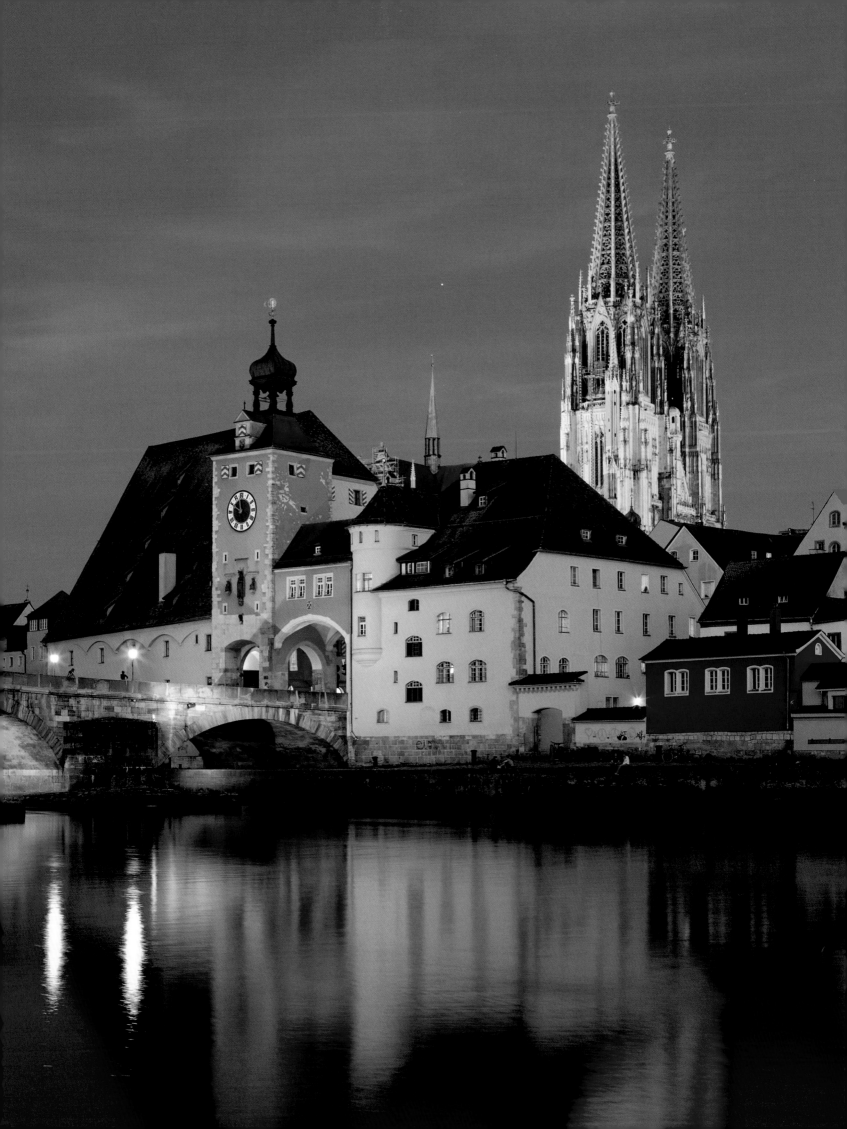

*Left-hand page:*
300 metres (985 feet) long and supported by 16 arches, the Stone Bridge in Regensburg has spanned the Danube since the middle of the 12th century. Behind it is the city's prominent landmark, the cathedral of St Peter. Construction on the church began after 1273.

*Below:*
House upon house and only a narrow passageway between: the narrow alleys in Regensburg demonstrate how economically one had to deal with the limited space within the protective walls of a medieval town.

*Below:*
The former Benedictine abbey in Prüfening – part of Regensburg since 1938 – was founded by Bishop Otto I of Bamberg (1109) and was subject to the Bamberg diocese until secularization. In 1897, remarkable 12th century frescoes were uncovered in what is now the parish church of St Georg.

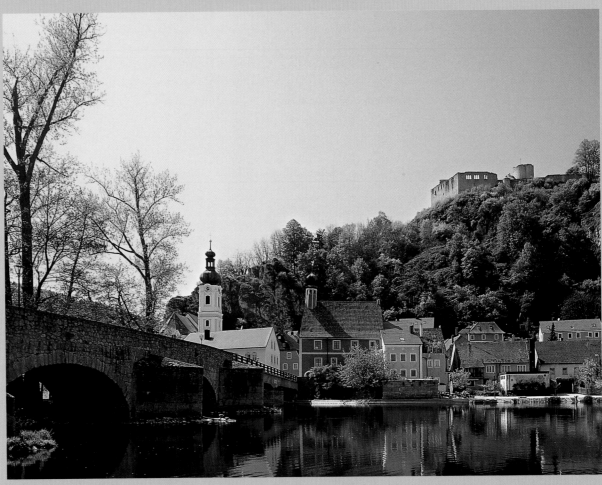

*Above:*
Burglengenfeld on the river Naab: an 11th century fortress gave the town its name. The castle itself was badly damaged in both the Landshut war of succession and the Thirty Years' War and was only saved due to the intervention of Crown Prince Ludwig.

*Right:*
Kallmünz, the "pearl of the Naab valley" lies where the Vils flows into the Naab. The natural close proximity of the castle ruin, the town and the river provides quite a romantic sight. The oldest part of the bridge is 500 years old.

*Above:*
The panorama of the meadows, fields and forests of the Danube valley from "Walhalla".

*Left:*
Weiden is the centre of the northeastern Upper Palatinate. First documented in 1241, it experienced an early heyday under Emperor Charles IV, who built the "Golden Road" linking Prague and Nuremberg through the town. The town hall in the middle of the broad street market was built in the Renaissance style between 1539 and 1545.

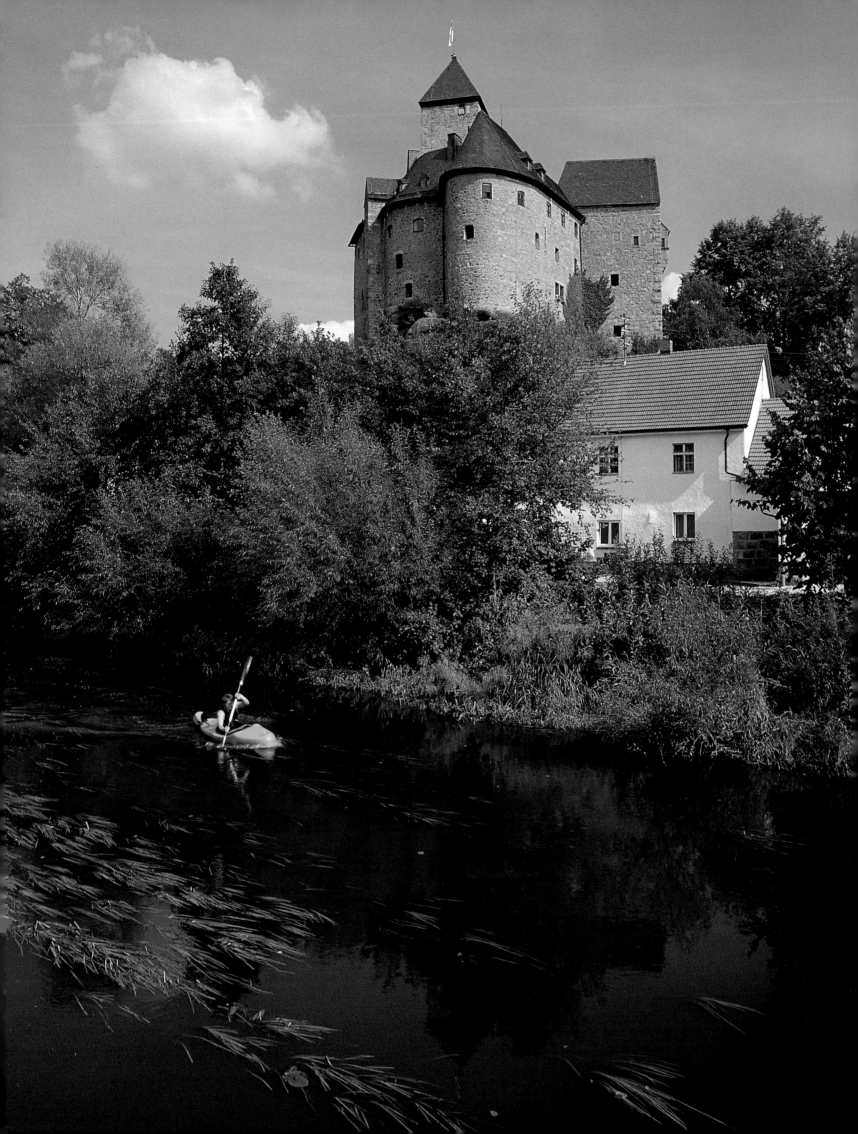

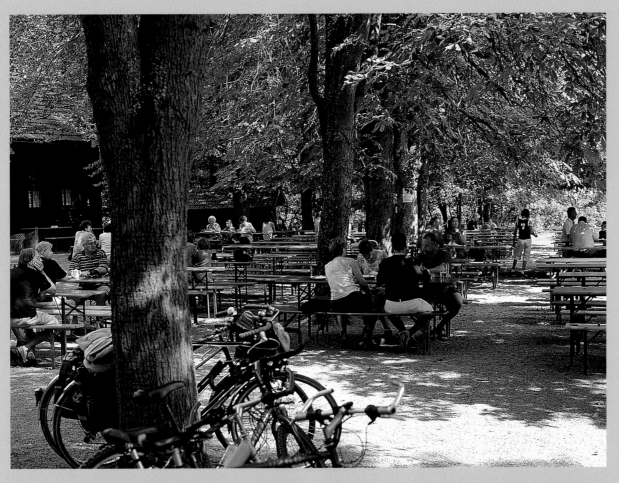

*Left-hand page:*
The steep cliffs upon which Castle Falkenberg was erected in the 12th century made defensive walls unnecessary. The complex fell into ruins for centuries before being saved in the 1930s by Count Friedrich von der Schulenburg, who was executed after the failed attempt on Hitler's life.

*Left:*
The "Blockhütte" beer garden near Falkenberg. Anyone who forgets that the Upper Palatinate has longed belonged to Bavaria will be reminded by the highly developed beer garden culture here.

*Far left:*
Once a frequent sight in the Upper Palatinate valleys, but a rarity today: a waterwheel.

*Left:*
In the Waldnaab Valley. Sometimes called the Bohemian Naab, the river's source is located near Bärnau in the Upper Palatinate. It unites with the Fichtelnaab streaming from the Fichtel Mountains and the Heidenaab that springs north of Kemnath to form the Naab, which then flows into the Danube above Regensburg.

**Above:**
**Before the horrible monster can be slain at the "Drachenstich" in Furth im Wald, the dragon gets a chance to spread terror among the townspeople.**

**Centre:**
**Dressed in traditional costumes, mostly handed down over generations, pilgrims parade with hymns and prayers through the fields near Maria Eck.**

**Below:**
**Bavarian festivals are unthinkable without brass bands.**

Only in Bavaria does one encounter a calendar of festivals so based on centuries-old traditions that are still valid today. The calendar begins in springtime with field processions and rich Easter customs. It keeps the fun of the May Tree alive just as the Whitsun Rides and the church patron festivals, the Rogation and other processions. It is no coincidence that Altötting is the most visited place of pilgrimage in all of Germany.

The feast of Corpus Christi is the grandest of the church festivals. There are not only processions on land, but on the water as well – on the Staffelsee. Even on this holy day, evil does not rest; therefore, during the annual Corpus Christi procession in Furth im Wald in the Upper Palatinate the knight Sir Kuno must slay the dragon as he always did. Since the mid-19th century, however, our hero must fight in August against a fire-breathing monster grown to 16 metres (52 feet) in length and three metres (10 feet) in height. It's no wonder that more people come every year to attend the execution – which helps compensate the extra expenses of the fireworks technicians.

While the occasion behind this spectacle is only speculated today, the "Landshut Prince's Wedding" recalls a real historic event: the marriage of Georg, the son of Ludwig the Rich, to the Polish king's daughter Hedwig in the year 1475. Poland and Bavaria competed to outdo one another. King Kazimierz IV arrived at the city gates with an entourage of nearly 700 men and 100 wagons for the baggage. Ludwig the Rich in turn took charge of the meals, leading to the slaughter of 40,000 chickens, over 1,000 sheep,

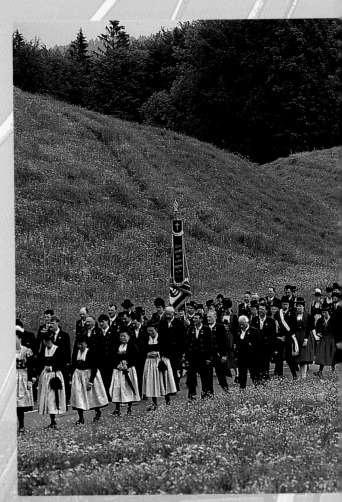

nearly 500 calves, more than 300 oxen and almost as many pigs.

## SUFFERING AND BLISS

The Agnes Bernauer Festival in Straubing harks back to another famous wedding. After a young gentleman (later Duke Albrecht III) ignored all considerations of rank and eloped with the beautiful barber's daughter Agnes, his father, the Duke, had to take criminal efforts to rid the world of the misalliance. He had his daughter-in-law condemned as a witch and drowned in the Danube.

# BAVARIA

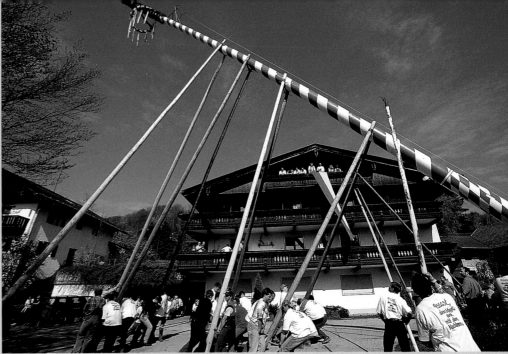

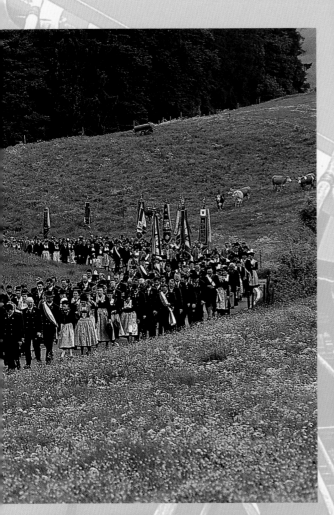

*Above:*
**Putting up the May Tree is an art that must be learned. It certainly generates a mighty thirst.**

*Left:*
**The parish church of Kreuth in the valley of the Tegern-see, the oldest shrine to the patron saint of cattle in Bavaria, is the destination of one of the best-known St Leonhard pilgrimages.**

*Left:*
**Although still early in the day, there are hardly any seats left in the beer garden by the Chinese Tower in Munich's English Garden.**

Although not subject to any specific historical event, the knightly tournaments in Kiefersfelden have been a popular attraction for generations. Germany's oldest historical plays began in the year 1618. Nevertheless, the stuff they are made of, that mixture of suffering and bliss, of life and death, presented with quite a bit of directness and lots of sentimentality, have the same effect today as in those days

**The famous Oberammergau Passion Play began with a vow made in 1633 during the plague and since then has been held every ten years.**

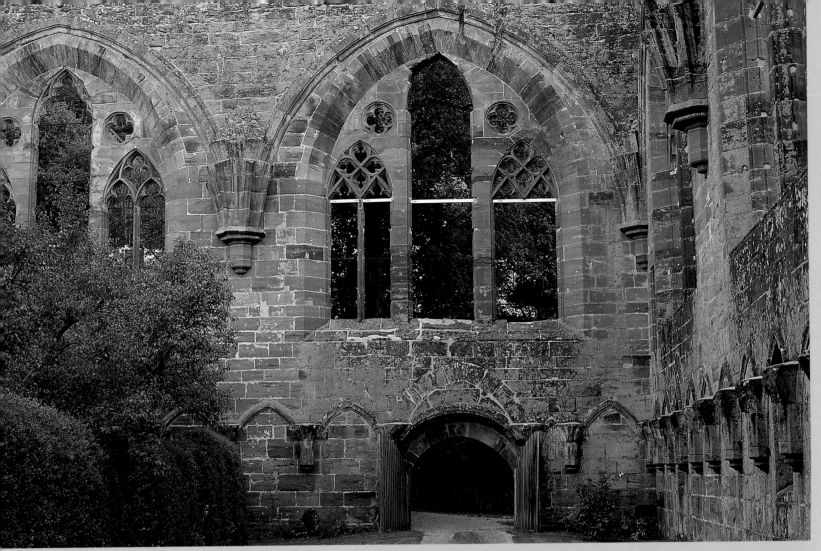

*Above:*
The impressive ruins of a former Brigittine convent are located in Gnadenberg in the district of Neumarkt in the Upper Palatinate. The first convent of the Brigittine order in southern Germany was founded here in 1426.

*Right:*
Karl Stilp is the name of the artist who skilfully and ironically decorated the library of the Waldsassen monastery with amazing carvings. The figures of Atlas that bear the gallery represent the bookmaking crafts.

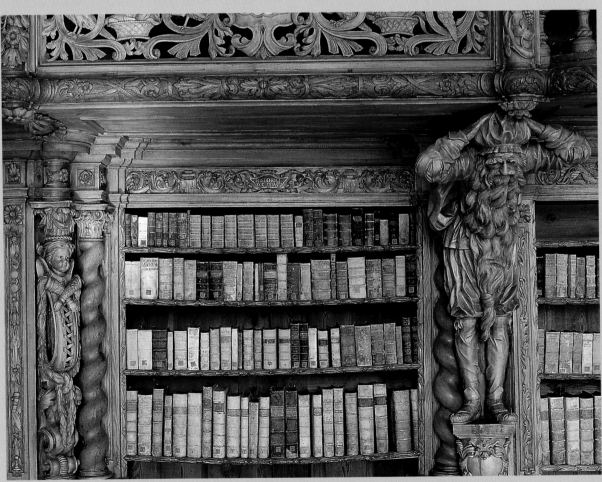

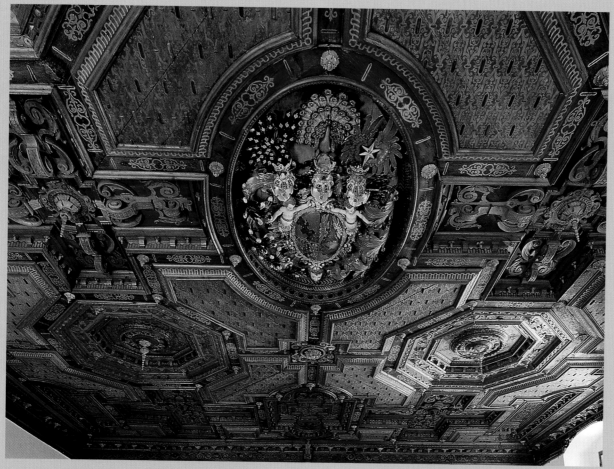

**Left:**
The Great Hall and the chapel of the Renaissance palace of Ortenburg in the Wolfach valley contain splendidly adorned coffer ceilings. The counts of Kraiburg-Ortenburg, who still reside in the complex today, were once among the most powerful Bavarian aristocratic families.

**Below:**
The Cistercian monastery of Fürstenzell in Lower Bavaria was founded in 1274. The eastern wing of the late-17th century building houses the library, which was decorated in almost ecstatic Rococo style.

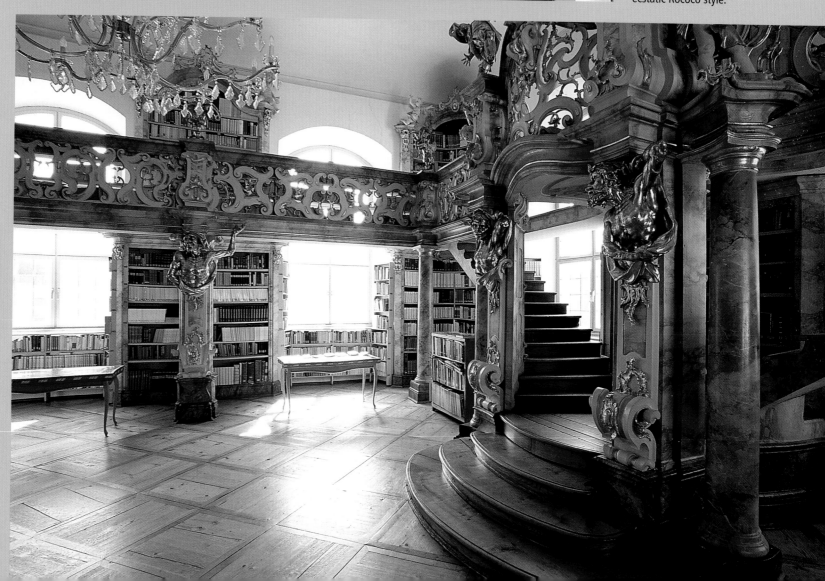

*Below:*
King Ludwig I had the idea for the Befreiungshalle (Liberty Hall) on the Michelsberg in Kelheim, while his architects Friedrich Gärtner and Leo von Klenze supplied the blueprints. It was handed over to the public in 1863 for the 50th anniversary of the Battle of Leipzig, a decisive defeat for Napoleon.

*Above right and centre:*
Before the Danube reached Kelheim it had to overcome a huge stone impediment over millions of years. It carved itself deep into the mountain to create an impressive ravine. Weltenburg monastery lies hidden within this narrow breach. The construction and decoration of the new monastery church in the early 18th century founded the reputation of the yet young Asam brothers as outstanding Baroque artists in Bavaria.

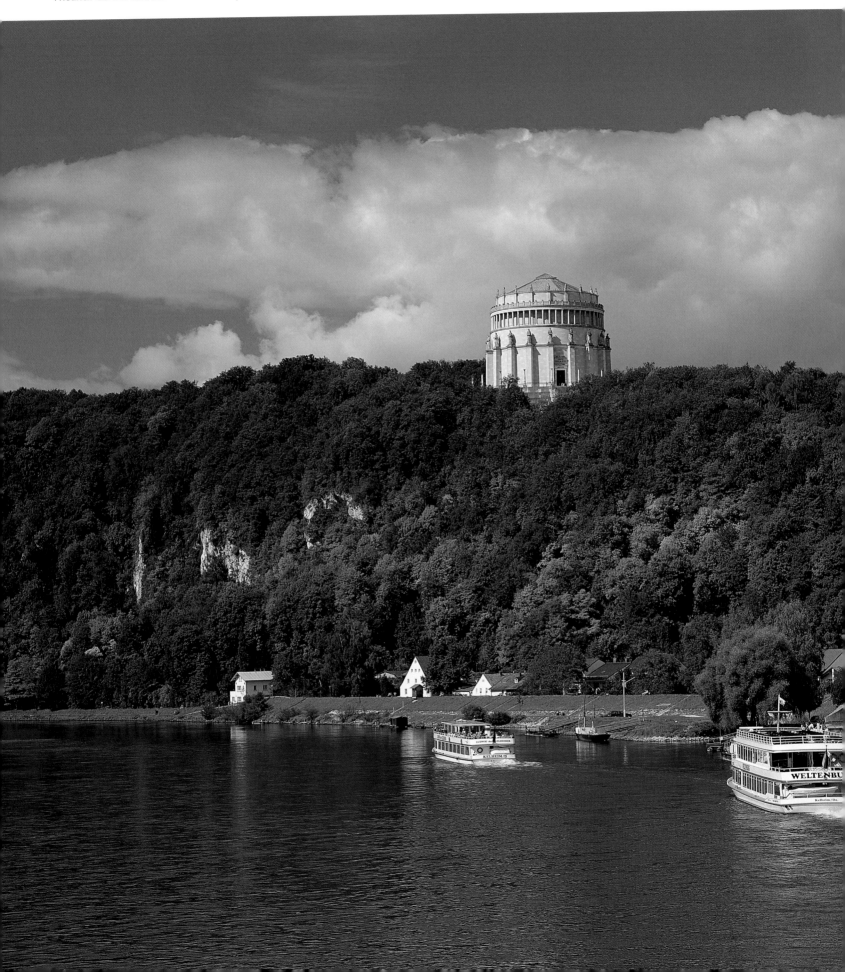

*Below right:*
Like the curling body of a huge serpent, the almost 200-metre (657-foot) long pedestrian bridge – the largest wooden bridge in Europe – crosses the Main-Danube Canal by Markt Essing. Only ruins remain of old Randeck Castle.

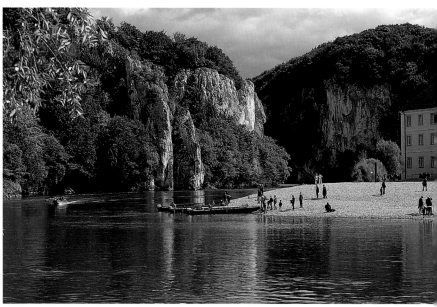

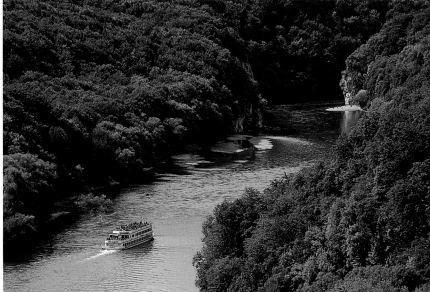

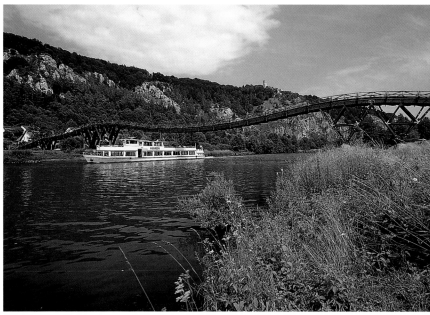

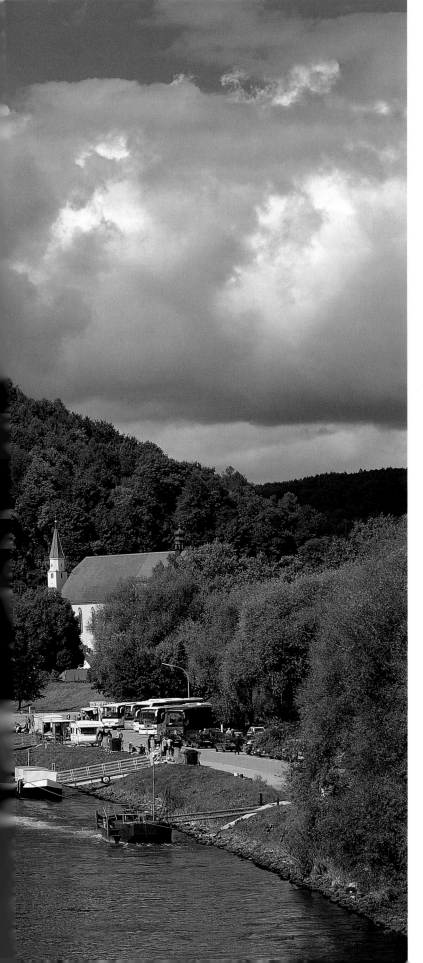

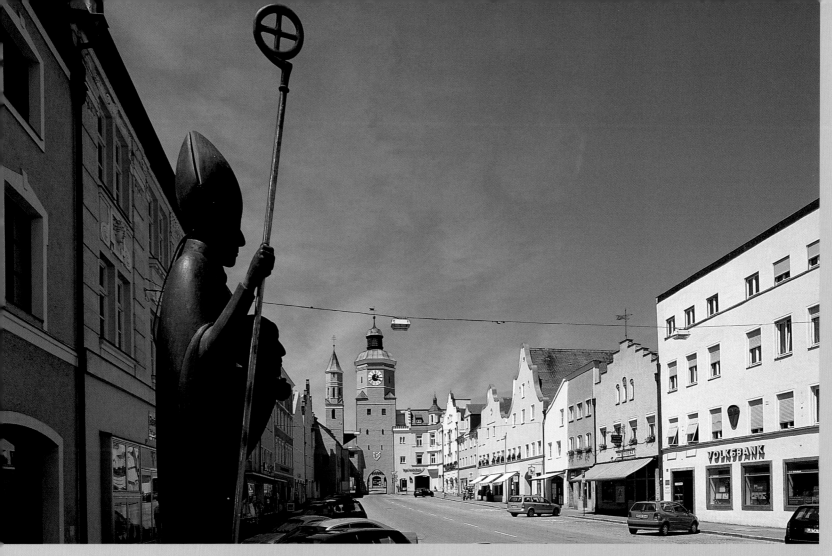

*Above:*
The great river Vils lent its name to the 1,000-year-old town of Vilsbiburg in the Lower Bavarian hills. The massive gate tower at the end of the historic town square was erected in the 16th century. Today it houses a local history museum, where one can also see the famous Kröninger earthenware.

*Right:*
Construction on Trausnitz Castle above Landshut began in the early 13th century. They say the minnesingers Neidhart von Reuenthal, Reinbot von Durne and Tannhäuser were once seen within its walls. In the 1570s, the wooden galleries in the castle courtyard were replaced by galleries of stone.

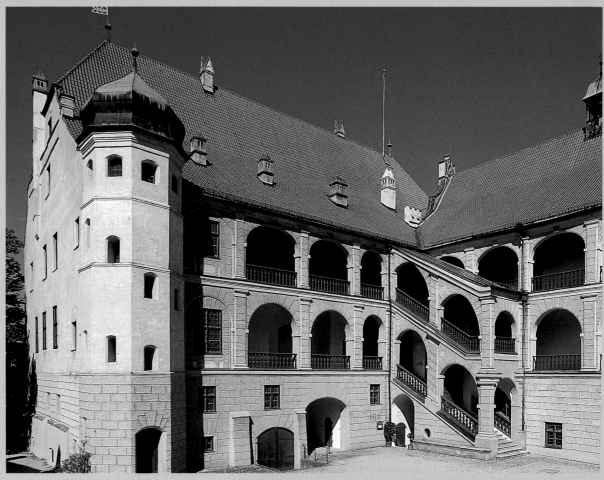

View of the Ludwigsplatz in Kelheim. The town in which the Altmühl and Danube rivers meet was first mentioned in documents in 866. The old seat of dukes lost significance, however, in the mid-13th century, when Otto II removed his residence to Landshut.

The legendary Count Abo, who is considered the founder of Abensberg (around the year 1000), is said to have had 32 children. The "gateway to the Hallertau" has a beautiful historic city centre. It is also known for its asparagus, which grows particularly well in the sandy soils.

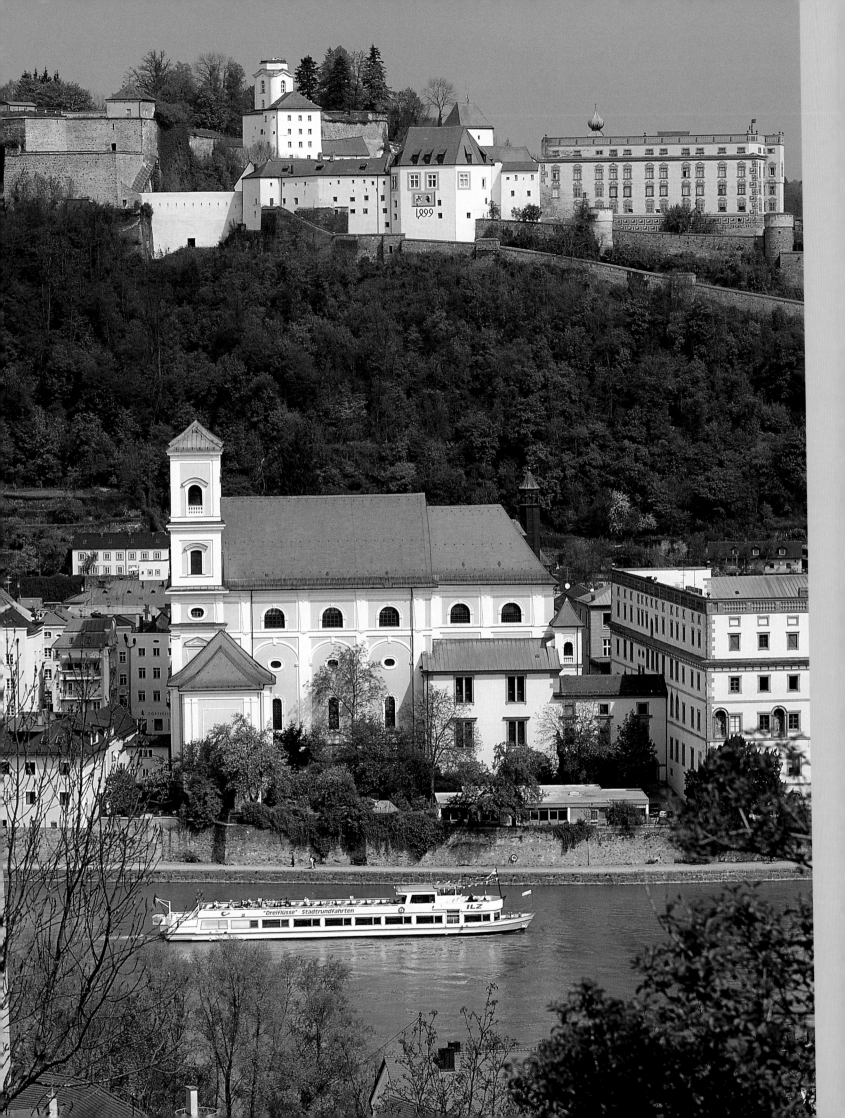

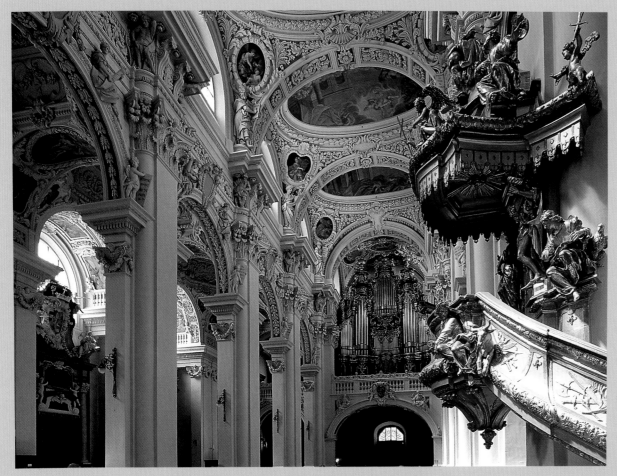

*Left-hand page:*
View across the Inn to the former Jesuit church of St Michael and the Veste (fortress) Oberhaus in Passau. Work was begun on the massive defensive complex in the 13th century. The buildings later served as a barracks and a prison, while today they house a museum.

The interior of the huge cathedral of St Stephan in Passau was decorated in the Baroque style in the late 17th century. G. B. Carlone and P. d'Aglio as well as 16 assistants needed eight years to complete the gushing stucco décor, which consists of approximately 1,000 figures and elements. The organ is another superlative. With 232 registers, it is one of the world's largest.

The Residence Square of Passau located behind the choir of the cathedral presents the imposing Neue Residenz as well as many other fine buildings grouped around the Wittelsbach fountain.

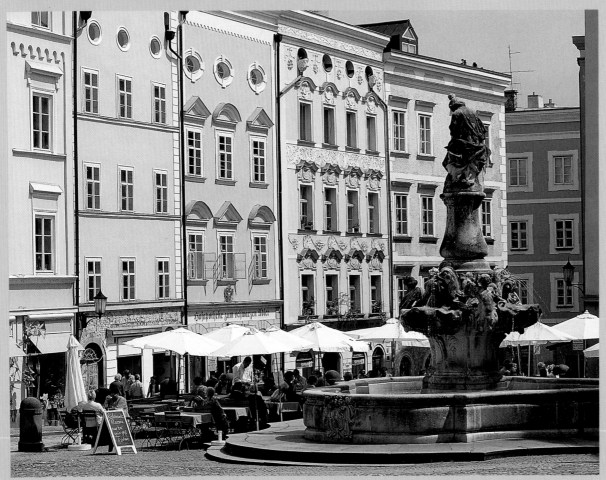

*Above:*
It is rarely this quiet on the two Arber lakes in the Bavarian Forest. Many people find their way here due to the tourism development of the region's highest summit, the 1,457-metre (4,784-foot) Grosse Arber.

*Right:*
The Bavarian Forest National Park is in the northeastern part of a large landscape conservation region and today encompasses roughly 25,000 hectares (62,000 acres). Today, it is again the home of animals that were once nearly eradicated by humans: lynxes and wolves, aurochs and bears.

*Left:*
The grazing aurochs feel obviously quite at home here, but only as long as people do not get in their way. For this reason, they – like the other "home-comers" in the Bavarian Forest National Park – are provided with large preserves where they can only be observed from specific points.

*Below:*
Deep in the forest of the Riesloch nature reserve near Bodenmais. No one better described this forest and its inhabitants than the poet Adalbert Stifter, who was born on 23 October 1805 in Oberplan in what is now the Czech Republic.

*Above:*
The summit of the Grosse Arber, with the Zwieseler lodge in the foreground. If the weather plays along, there is a grand view from here to the Erzgebirge in the north and the Alps in the south.

*Right:*
Like so many other boulders, the secret to this one near Solla in the Bavarian Forest is to know or discover the spot from where you can budge it.

*Above:*
The Grosse Arber is in a way the weather vane on "Europe's green roof" – as the largest connected forest mountain range of our continent is sometimes called. The powers of nature have bared the rocky subsoil and when the few trees up here grow, it's certainly not skywards.

*Left:*
A fascinating open-air museum welcomes visitors to the Drei-burgen Lake near Tittling. Roughly fifty houses, farm buildings and workshops convey a living image of the once ardu-ous living and working conditions of the inhabitants of the Bavarian Forest.

# INDEX

154

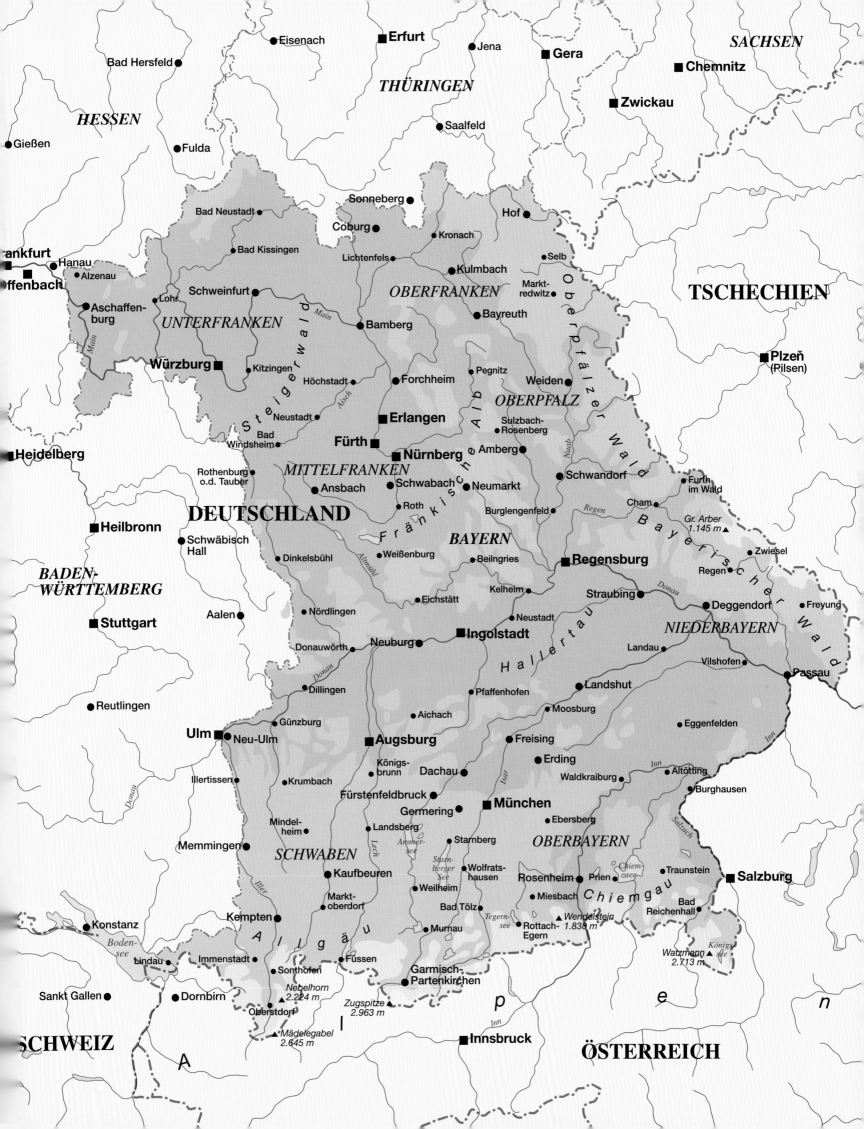

# CREDITS

**Book design**
SILBERWALD
Agentur für visuelle Kommunikation, Würzburg

**Map**
Fischer Kartografie, Aichach

Translation
Faith Gibson Tegethoff, Swisttal

Printed in Germany
Repro: Artilitho, Trento-Lavis, Italy
Printed/Bound by: Offizin Andersen Nexö, Leipzig

© 2008 Verlagshaus Würzburg GmbH & Co. KG
© Photos: Martin Siepmann

ISBN 978-3-8003-1887-2

www.verlagshaus.com

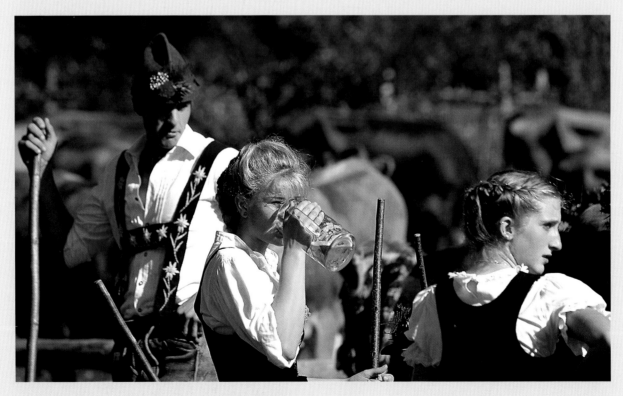

Sorting the cattle in Oberstaufen. In a region where cattle
play such a pivotal economic role as here in Allgäu dairy land,
it's natural that such an important event in the farming year
be properly celebrated.